CW00547252

Grammar and punctuation

Teacher's Resource Book

Recommended system requirements:

Windows: XP (Service Pack 3), Vista (Service Pack 2), Windows 7 or Windows 8 with 2.33GHz processor
Mac: OS 10.6 to 10.8 with Intel Core™ Duo processor
1GB RAM (recommended)
1024 x 768 Screen resolution
CD-ROM drive (24x speed recommended)
Adobe Reader (version 9 recommended for Mac users)
Broadband internet connections (for installation and updates)

For all technical support queries (including no CD-drive), please phone Scholastic Customer Services on 0845 6039091.

Author

Huw Thomas and Paul Hollin

Editorial Team

Rachel Morgan, Melissa Somers,
Jenny Wilcox, Marion Archer,
Suzanne Adams, Red Door Media Ltd

Series designers

Shelley Best and Anna Oliwa

Design team

Nicolle Thomas and Andrea Lewis

Illustrations

Moreno Chiacchiera/Beehive Illustration

**CD-ROM design and
development team**

Hannah Barnett, Phil Crothers
MWA Technologies Private Ltd

Designed using Adobe Indesign
Published by Scholastic Ltd,
Book End, Range Road, Witney,
Oxfordshire OX29 0YD
www.scholastic.co.uk

Printed by Ashford Colour Press
© 2015 Scholastic Ltd
1 2 3 4 5 6 7 8 9 0 5 6 7 8 9 0 1 2 3 4

British Library Cataloguing-in-Publication Data

A catalogue record for this book is available from
the British Library.
ISBN 978-1407-14068-1

Acknowledgements

The publishers gratefully acknowledge permission to reproduce
the following copyright material:

David Higham Associates for the use of an extract from *Dear
Olly* by Michael Morpurgo (2000, HarperCollins).
Johnson and Alcock Ltd for the use of an extract from *The
Lamplighter's Funeral* by Leon Garfield. Copyright © the Estate
of Leon Garfield, 1976. Reproduced with the kind permission of
Johnson & Alcock Ltd.
Random House Group Limited for the use of an extract from
The Story of Tracy Beaker by Jacqueline Wilson. Published by Corgi
Children's and reproduced by permission of The Random House
Group Ltd.
Rupert Crew Ltd for the use of an extract from *The Trickster's
Handbook* by Peter Eldin (1976, Armada).
United Agents for the use of the poem 'Busy Day' by Michael
Rosen first published in *You Tell Me* (1981, Puffin Books).

Every effort has been made to trace copyright holders for the
works reproduced in this book, and the publishers apologise for
any inadvertent omissions.

Extracts from *The National Curriculum in English, English
Programme of Study* © Crown Copyright. Reproduced under
the terms of the Open Government Licence (OGL). http://www.
nationalarchives.gov.uk/doc/open-government-licence/open-
government-licence.htm

Contents

Chapter 1
Words at work

Chapter 2
Adjectives and prepositions

Chapter 3
Verbs and verb tenses

Chapter 4
Clauses and sentences

Chapter 5
Cohesion

Chapter 6
Punctuation

Introduction

Scholastic English Skills: Grammar and punctuation

This series is based on the premise that grammar and punctuation can be interesting and dynamic – but on one condition. The condition is that the teaching of these grammar aspects must be related to real texts and practical activities that experiment with language, investigate the use of language in realistic contexts and find the ways in which grammar and punctuation are used in our day-to-day speech, writing and reading. This book encourages children to look back at their written work and find ways to revise and improve it.

Teaching grammar and punctuation

'As a writer I know that I must select studiously the nouns, pronouns, verbs, adverbs, etcetera, and by a careful syntactical arrangement make readers laugh, reflect or riot.'

Maya Angelou

The *Scholastic English Skills: Grammar and punctuation* series equips teachers with resources and subject training to enable them to teach grammar and punctuation effectively. The focus of the resource is on what is sometimes termed 'sentence-level work', so called because grammar and punctuation primarily involve the construction and understanding of sentences.

Many teachers bring with them a lot of past memories when they approach the teaching of grammar. Some will remember school grammar lessons as the driest of subjects, involving drills and parsing, and will wonder how they can make it exciting for their own class. At the other end of the spectrum, some will have received relatively little formal teaching of grammar at school. In other words, there are teachers who, when asked to teach clause structure or prepositions, feel at a bit of a loss. They are being asked expectantly to teach things they are not confident with themselves.

Grammar can evoke lethargy, fear, irritation, pedantry and despondency. Yet as demonstrated by the above comment from Maya Angelou, even one of our greatest modern writers presents her crafting of sentences as an exciting and tactical process that has a powerful effect on her readers. Can this be the grammar that makes teachers squirm or run?

About the product

The book is divided into six chapters. Each chapter looks at a different aspect of grammar and punctuation and is divided into sections. Each section includes teachers' notes – objective, background knowledge, notes on how to use the photocopiable pages, further ideas and digital content – and up to three photocopiable pages.

Posters

Each chapter has two posters. These posters are related to the contents of the chapter and should be displayed and used for reference throughout the work on the chapter. The poster notes (on the chapter introduction page) offer suggestions for how they could be used. There are black and white versions in the book and full-colour versions on the CD-ROM for you to print out or display on your whiteboard.

Activities

Each section contains three activities. These activities all take the form of a photocopiable page which is in the book. Each photocopiable page is also included on the CD-ROM for you to display or print out (answers are also provided, where appropriate, in a separate document on the CD-ROM).

Many of the photocopiable pages have linked interactive activities on the CD-ROM. These interactive activities are designed to act as starter activities to the lesson, giving whole-class support on the information being taught. However, they can also work equally well as plenary activities, reviewing the work the children have just completed.

Workbooks

Accompanying this series is a set of workbooks containing practice activities which are divided into chapters to match the teacher's resource book. Use a combination of the photocopiable pages in this book and the activities in the workbook to help children practise and consolidate grammar and punctuation skills.

To complete the installation of the program you need to open the program and click 'Update' in the pop-up. Please note – this CD-ROM is web-enabled and the content will be downloaded from the internet to your hard-drive to populate the CD-ROM with the relevant resources. This only needs to be done on first use, after this you will be able to use the CD-ROM without an internet connection. If at any point any content is updated you will receive another pop-up upon start up with an internet connection.

Main menu

The main menu is the first screen that appears. Here you can access: terms and conditions, registration links, how to use the CD-ROM and credits. To access a specific year group click on the relevant button (NB only titles installed will be available). To browse all installed content click **All resources**.

Chapter menu

The Chapter menu provides links to all of the chapters or all of the resources for a specific year group. Clicking on the relevant Chapter icon will take you to the section screen where you can access the posters and the chapter's sections. Clicking on **All resources** will take you to a list of all the resources, where you can search by keyword or chapter for a specific resource.

Section menu

Here you can choose the relevant section to take you to its activity screen. You can also access the posters here.

Using the CD-ROM

Below are brief guidance notes for using the CD-ROM. For more detailed information, see 'How to use this digital content' on the Main menu.

The CD-ROM follows the structure of the book and contains:

- All of the photocopiable pages.
- All of the poster pages in full colour.
- Answers provided, where relevant.
- Interactive on-screen activities linked to the photocopiable pages.

Getting started

Put the CD-ROM into your CD-ROM drive.

- For Windows users, the install wizard should autorun, if it fails to do so then navigate to your CD-ROM drive. Then follow the installation process.
- For Mac users, copy the disk image file to your hard drive. After it has finished copying double click it to mount the disk image. Navigate to the mounted disk image and run the installer. After installation the disk image can be unmounted and the DMG can be deleted from the hard drive.
- To install on a network, please see the ReadMe file located on the CD-ROM (navigate to your drive).

Activity menu

Upon choosing a section from the section menu, you are taken to a list of resources for that section. Here you can access all of the photocopiable pages related to that section as well as the linked interactive activities.

All resources

All resources lists all of the resources for a year group (if accessed via a Chapter menu) or all of the installed resources (if accessed via the Main menu). You can:

● Select a chapter and/or section by selecting the appropriate title from the drop-down menus.
● Search for key words by typing them into the search box.
● Scroll up or down the list of resources to locate the required resource.
● To launch a resource, simply click on the **Go** button.

Navigation

The resources (poster pages, photocopiable pages and interactive activities) all open in separate windows on top of the menu screen. To close a resource, click on the **x** in the top right-hand corner of the screen and this will return you to the menu screen.

Closing a resource will not close the program. However, if you are in a menu screen, then clicking on the **x** will close the program. To return to a previous menu screen, you need to click on the **Back** button.

Teacher settings

In the top left-hand corner of the Main menu screen is a small **T** icon. This is the teacher settings area. It is password protected, the password is: login. This area will allow you to choose the print quality settings for interactive activities 'Default' or 'Best'. It will also allow you to check for updates to the program or re-download all content to the disk via **Refresh all content**.

Answers

The answers to the photocopiable pages can be found on the CD-ROM in the All resources menu. The answers are supplied in one document in a table-format, referencing the page number, title and answer for each relevant page. The pages that have answers are referenced in the 'Digital content' boxes on the teachers' notes pages. Unfortunately, due to the nature of English, not all pages can have answers provided because some activities require the children's own imaginative input or consist of a wider writing task.

Objectives

Chapter	Page	Section	English skills objective	To use the perfect form of verbs to mark relationships of time and cause.	To use expanded noun phrases to convey complicated information concisely.	To use modal verbs or adverbs to indicate degrees of possibility.	To convert nouns or adjectives into verbs using suffixes.	To use verb prefixes.
Chapter 1	12	Word classes	Revisit different word classes.					
Chapter 1	16	Changing nouns or adjectives into verbs	Convert nouns or adjectives into verbs using suffixes.				✓	
Chapter 1	20	Verb prefixes	Understand how to add prefixes to verbs.				✓	✓
Chapter 1	24	Expanding noun phrases	Use expanded noun phrases to convey information concisely.		✓			
Chapter 1	28	Making words work	Develop use of prefixes and suffixes, and experiment with word classes and expanded noun phrases to improve sentences.		✓		✓	✓
Chapter 2	35	Adjectives	Revisit and consolidate understanding of adjectives.		✓			
Chapter 2	39	Using adjectives	Extend the use of adjectives in writing.		✓			
Chapter 2	43	Prepositions	Understand the function of and identify prepositions.		✓			
Chapter 2	47	Using prepositions	Use prepositions in writing.		✓			
Chapter 2	51	Developing adjectives and prepositions	Select adjectives carefully to improve writing, and develop the use and range of prepositions.		✓			
Chapter 3	58	Making sure the verb agrees	Use correct subject and verb agreement when using singular and plural.	✓				
Chapter 3	62	Checking verb tense in writing	Use correct tense and ensure consistent use of tense throughout writing.	✓				
Chapter 3	66	What is a modal verb?	Identify modal verbs and understand their function in a sentence.			✓		
Chapter 3	70	Writing with modal verbs and adverbs	Use modal verbs and adverbs to express possibility in writing.			✓		
Chapter 3	74	Verbs in writing	Use verb forms and verb tenses accurately in writing, and use verbs and adverbs to indicate degrees of possibility.	✓		✓		

Objectives

	Page	Section	English skills objective	To use relative clauses beginning with 'who', 'which', 'where', 'when', 'whose', 'that' or with an implied (omitted) pronoun.	To use commas to clarify meaning or avoid ambiguity in writing.	To use brackets, dashes or commas to indicate parenthesis.	To punctuate bullet points correctly.	To use devices to build cohesion within a paragraph.	To link ideas across paragraphs using adverbials of time, place and number or tense choices.
Chapter 4	81	Revisiting clauses	Revisit clauses.	✓					
	85	What are relative pronouns and relative clauses?	Identify relative pronouns and relative clauses.	✓					
	89	Using relative clauses	Use relative clauses in writing.	✓	✓	✓			
	93	Extending sentences using clauses	Consolidate and extend work on using clauses in writing.	✓		✓			
	97	Clauses in writing	Use the concept of a clause as a tool for shaping sentences, including relative clauses.	✓		✓			
Chapter 5	104	Building cohesion into writing	Develop understanding of cohesion and begin to build cohesion within paragraphs.					✓	
	108	Adverbials	Revisit adverbials.					✓	✓
	112	Linking ideas across paragraphs	Link ideas across paragraphs.					✓	✓
	116	Text structure	Use organisational and presentational devices to structure text.				✓	✓	
	120	Helping the reader	Consider how to build cohesion within and across paragraphs.					✓	✓
Chapter 6	127	Brackets, dashes and commas	Identify and begin to understand the use of brackets, dashes or commas to indicate parenthesis.			✓			
	131	Using parenthesis in writing	Develop the use of parenthesis in writing.			✓			
	135	Commas in writing	Use commas to clarify meaning or avoid ambiguity.		✓	✓			
	139	Revisiting punctuation	Revisit punctuation.		✓	✓			
	143	Refining punctuation in writing	Consolidate and extend the use of punctuation in writing.		✓	✓			

Words at work

Introduction

This chapter deals with tricky aspects of grammatical knowledge – word classes and how they can be used and changed to convey information accurately and concisely. As well as developing their understanding of terminology, children are challenged to consider the precise meaning of words as they are changed by adding prefixes and suffixes, particularly verbs. This is followed with work on expanded noun phrases and a wide range of ideas and opportunities to help children put this knowledge and these skills to good use in their writing. For further practice, please see the 'Words at work' section of the Year 5 workbook.

In this chapter

Word classes page 12	Revisit different word classes.
Changing nouns or adjectives into verbs page 16	Convert nouns or adjectives into verbs using suffixes.
Verb prefixes page 20	Understand how to add prefixes to verbs.
Expanding noun phrases page 24	Use expanded noun phrases to convey information concisely.
Making words work page 28	Develop use of prefixes and suffixes, and experiment with word classes and expanded noun phrases to improve sentences.

Poster notes

Word classes (page 10)
This poster provides up-to-date definitions of word classes. Display it in the classroom and use it as a reference when analysing sentences or if working at word level.

Using prefixes and suffixes to make verbs (page 11)
As well as acting as a reminder about the definition and use of prefixes and suffixes, this poster exemplifies how prefixes can be used to alter the meaning of verbs (note that there are many possibilities for this and the poster only highlights key examples). The poster also illustrates how suffixes can convert nouns and adjectives to verbs, focusing on the four key suffixes, 'ise', 'ify', 'ate' and 'en'.

Vocabulary

Children should already know:
adjective, adverb, determiner, noun, preposition, pronoun, verb, prefix, suffix, noun phrase, word family, word class
In Year 5 children need to know:
clause (relative), homonym, modify/modified

Words at work

Word classes

Conjunction
Conjunctions are used to link words, phrases or clauses together.

Verb
Verbs describe actions. They can convey information about the past, present or future.

Adjective
Adjectives can be used before a noun to help describe it, or after the verb 'be', as its complement.

Preposition
Prepositions often describe locations or directions, but can also describe other things such as events in time.

Adverb
Adverbs can be used to modify a verb, an adjective, another adverb or even a whole clause. They help to describe actions or events more clearly.

Noun
Nouns give names to people, places, things and feelings. They can be common, proper, countable or non-countable, and can always be used with a determiner.

Determiner
Determiners tell us if a noun is known or unknown, general or specific.

Words at work

Using prefixes and suffixes to make verbs

■ Look at the verbs below made by adding prefixes or suffixes. Can you make sentences with them?

Prefixes

There are lots of prefixes we can add to the start of verbs to make new verbs.

Look at the ones below and decide what they mean.

Notice that the spellings do not change when they are added.

appear – reappear, disappear

build – rebuild

connect – disconnect

estimate – underestimate

exist – co-exist

fasten – refasten, unfasten

inform – misinform

run – overrun, outrun

sleep – oversleep

value – devalue, undervalue

visit – revisit

work – overwork

Suffixes

There are some suffixes we can add to the end of adjectives or nouns to make verbs.

The main ones are: ate, en, ify, ise.

Look at how the spellings of some of the verbs change.

dark – darken

dead – deaden

length – lengthen

apology – apologise

energy – energise

magnet – magnetise

medicine – medicate

operation – operate

pollen – pollinate

pure – purify

simple – simplify

solid – solidify

Word classes

Objective

Revisit different word classes.

Background knowledge

A word like 'kick' cannot be simply labelled 'a verb'. Words can perform different functions, depending on the context in which they are used: 'kick' can be a verb in *kick the ball* and a noun in *give the ball a kick*. By looking at the definitions of the functions of various classes of words it is possible to decide which words are functioning as nouns, adjectives and so on, depending upon the context.

Activities

● **Photocopiable page 13 'Wordsorts'**
Through using the sets on this photocopiable sheet children can group together examples of words performing certain functions in sentences. They should be encouraged to do this with a range of texts, setting out with the purpose of finding examples of the various word classes.

● **Photocopiable page 14 'Word function'**
The passages in this activity have been selected to provide text extracts using varied word types, though through looking at them children may gain an idea of which word types are more common than others. Once they have sorted the words picked out in the activity they could go on to find other examples of each word class.

● **Photocopiable page 15 'Word-type choosing'**
The object of this activity isn't so much to guess the missing word as to guess what type of word it could be. Children have to ask what job could be done by a word in that context. Once they have completed this they may like to create an example of their own to set others, drawing upon the different types of word function they have encountered.

Further ideas

● **Word changes:** Children can look at sentences in texts, such as stories, and see which words they could change. Ask: *Could you find a better word than one of the ones used? Could you be more descriptive?* They could add to this activity the challenge of thinking about how easy it is to change certain types of word without altering the underlying meaning of the sentence. Are verbs easier to change than nouns?

● **Word colours:** Children can find newspaper articles and comic stories and try shading over different word types in different colours. If they work with a partner there will be the added discussion of some of the choices thrown up by this activity.

● **Parts in sentences:** Ask the children to try writing sentences that contain a determiner, noun, verb, adjective, adverb, preposition and pronoun. They might write the different types of word in different colours for easy identification.

Digital content

On the digital component you will find:
● Printable versions of all three photocopiable pages.
● Answers to 'Word function' and 'Word-type choosing'.
● Interactive version of 'Word-type choosing'.

Word classes

Wordsorts

a story an article a brochure or another text

■ Look at some different types of text, such as those shown above.
■ Find words doing the jobs shown in these boxes.
■ Copy the words into the boxes.

Nouns Nouns give names to people, places, things or can be abstract like 'happiness'.	**Verbs** Verbs describe actions. They can convey information about the past, present or future.
Adjectives Adjectives can be used before a noun to help describe it, or after the verb 'be'.	**Adverbs** Adverbs help to describe actions or events more clearly.

Name:

Word classes

Word function

- Look at the bold words in these extracts.
- List the nouns, verbs, adjectives, adverbs, prepositions, conjunctions and determiners in the table.

Possul **gazed** at the lamplighter, whose flame-lit countenance resembled **an angry** planet in the gloom; **then** his eyes strayed to **Pallcat's** lamps that **winked** in the **obscure** air **down** either side of the Strand. It took sharp eyes to make them out, they glimmered so **feebly** within the accumulated filth of **the** glass that **enclosed** them. Although they complied with the letter of the law and burned from **sunset** to sunrise, they **mocked** the **spirit** of the law and provided not the smallest scrap of illumination. If ever **a** world **walked** in need of light, it was the world under Pallcat's **lamps**.

Leon Garfield: *The Lamplighter's Funeral*

Hands Up:
Get a friend to stand in **a** doorway **and** to push the backs of his hands against **the** door frame as **hard** as he can. Keep him there **for** at least a minute and make sure that he is pushing hard all the time.

Now tell him to **relax** the pressure and move away from the door. As he **does** so both of his **hands** will rise in the air **as if** pulled by **invisible** strings.

Peter Eldin: *The Trickster's Handbook*

Nouns	Verbs	Adjectives	Adverbs

Prepositions	Conjunctions	Determiners

Word classes

Word-type choosing

■ Look at this passage. What type of word could be used in each space? Suggest actual words that could fill the spaces.

My ☐ 1 ☐ was in the teacher's desk but I had to get it back so I did a ☐ 2 ☐ thing. I tried to steal it back. After school I ☐ 3 ☐ in the playground ☐ 4 ☐ all the teachers left. It was a ☐ 5 ☐ day and I shivered. I waited and waited ☐ 6 ☐. When they had all gone I crept ☐ 7 ☐ through the door and ☐ 8 ☐ the classroom. I opened the desk ☐ 9 ☐ suddenly heard someone coming so I ☐ 10 ☐ hid under the table. It was the caretaker. He was a ☐ 11 ☐ bloke and I didn't want to cross him. He looked around ☐ 12 ☐ switched the lights off and ☐ 13 ☐ the door. I suddenly realised I was locked in this ☐ 14 ☐ building.

Type of word	My suggestion
1	
2	
3	
4	
5	
6	
7	
8	
9	
10	
11	
12	
13	
14	

Changing nouns or adjectives into verbs

Objective

Convert nouns or adjectives into verbs using suffixes.

Background knowledge

Word families can be complex and confusing. Appreciating that identical words (such as 'swim') can belong to different classes, and that words can have their meanings, and class, changed by adding letters to them are fundamental to understanding the structure of the English language.

This section introduces this concept via homonyms, and then focuses on the four main suffixes used to create verbs from nouns and adjectives, encouraging children to think about the meanings of the suffixes and consider rules for their use. These suffixes are 'ise', 'ify', 'ate' and 'en'.

Activities

● **Photocopiable page 17 'Homonyms'**
Recognising that the same word can belong to different classes is an important foundation for appreciating word families, moving on to the creation of new words by adding suffixes. This page presents a range of words that are homonyms alongside some words that are not. The task is to identify the homonyms and state their different classes. This can be extended by asking children to write a sentence for each one.

● **Photocopiable page 18 'How was it made?'**
This activity presents children with a selection of sentences that contain verbs created by adding suffixes to adjectives and nouns (all of the words appear on poster page 11 'Using prefixes and suffixes to make verbs'). Children are challenged to identify the verbs and to show how they are made, prompted by an initial example. This can be extended by creating sentences using other words from the poster and breaking down these verbs too, or indeed with new verbs.

● **Photocopiable page 19 'Getting verbal'**
This simple sheet provides a collection chart for children to collect verbs made from nouns and adjectives. Using this will encourage children to consider where the verb came from (the noun or adjective is shown in brackets in the examples), and to remember spelling patterns.

Further ideas

● **New verbs:** For the duration of the children's work with verbs created from other words put aside ten minutes or so per day and have the children scan their reading books, or other material, for such words. Build up a display of them, underlining the affixes and writing meanings if appropriate. (Photocopiable page 19 'Getting verbal' can support this.)

● **Invented verbs:** Challenge children to create their own verbs by adding suffixes to adjectives or nouns and to create a dictionary definition for them. For example: *sausagify* – verb, to turn something into a sausage-like shape or substance. While somewhat frivolous, this exercise can reinforce dictionary skills as children will need to double check that their words do not already exist. (The activity on photocopiable page 30, 'Verb magic', focuses on this too.)

Digital content

On the digital component you will find:
● Printable versions of all three photocopiable pages.
● Answers to 'Homonyms' and 'How was it made?'.
● Interactive versions of 'Homonyms' and 'How was it made?'

Name:

Homonyms

A true homonym is a word that has more than one meaning even though it looks and sounds the same. Each meaning of the word should work in a different sentence if it is a true homonym.

For example: *She read a book*, or, the *referee can book a player*. The first 'book' is a noun, the second 'book' is a verb.

■ Some of the words below are homonyms that are nouns as well as verbs – can you identify them?

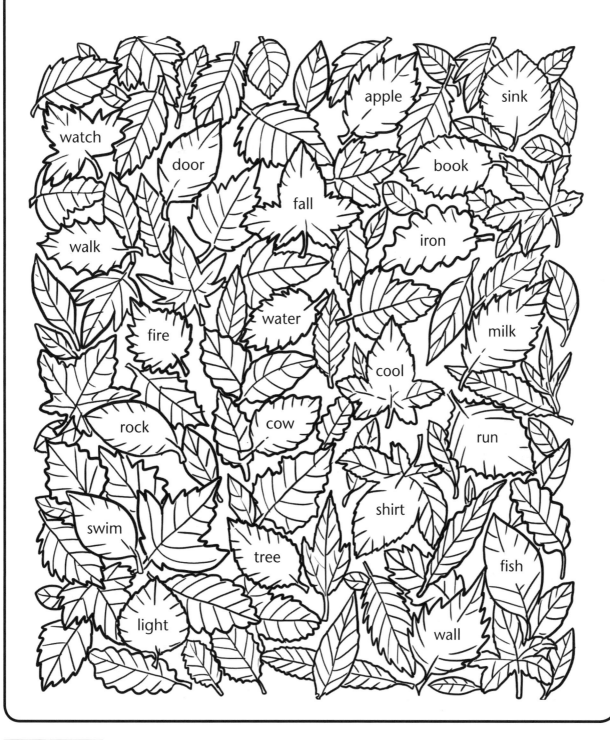

Name:

Changing nouns or adjectives into verbs

How was it made?

■ Each of the sentences below contains a verb that has been made by adding a suffix to an adjective or a noun. Your challenge is to identify the verb and show how it was made.

Example:
There is no need to apologise – you have done nothing wrong.

Verb: _apologise_ From: _noun – apology_ Suffix: _ise_

1. I don't understand the question. Could you simplify it?

Verb: _____ From: _____ Suffix: _____

2. We need to operate because he has a terrible pain in his tummy.

Verb: _____ From: _____ Suffix: _____

3. If you close the curtains it will darken the room.

Verb: _____ From: _____ Suffix: _____

4. We need bees to pollinate the flowers and plants.

Verb: _____ From: _____ Suffix: _____

5. Next, pull the dough at both ends to lengthen it.

Verb: _____ From: _____ Suffix: _____

Getting verbal

■ Use this chart to collect verbs made by adding suffixes to nouns and adjectives.
Some words have been included to get you started.

Suffix	Examples
ise	apologise (apology)
ify	falsify (false)
ate	captivate (captive)
en	deepen (deep)

Verb prefixes

Objective

Understand how to add prefixes to verbs.

Background knowledge

The previous section looked at how suffixes can be used to create new words with different meanings and class, with a focus on the creation of verbs.

The existence of homonyms increases the difficulty for children to assimilate these words. In addition, existing verbs can take on prefixes that create new verbs with altered meanings, this being dependent on the meaning of the original verb and also on that of the prefix.

Most common are the following prefixes, presented here with their meanings:
- 'dis' – do the opposite of, such as 'disappear'
- 'de' – do the opposite of, such as 'deselect'
- 'mis' – badly or wrongly, such as 'mislead'
- 'over' – too much, such as 'overact'
- 're' – again or back, such as 'rebuild'.

Activities

● **Photocopiable page 21 'Prefix hunt'**
In this activity children are asked to read two short passages and identify all verbs that have been made using prefixes (all of the words appear on poster page 11 'Using prefixes and suffixes to make verbs'). They then rewrite these at the bottom of the sheet, showing the prefix and root verb separately.

● **Photocopiable page 22 'Meaning matters'**
Children create new verbs by matching a prefix to an existing verb, and then match this to the correct meaning for the verb. This activity can be extended by asking children to write a sentence for each verb, perhaps altering tenses to accommodate the suffixes 'ing', 'ed' and so on.

● **Photocopiable page 23 'Constructing verbs'**
This activity involves sentences where prefixes are missing from a selection of verbs. Children must insert the correct prefix and then complete the sentence to ensure it makes sense.

Further ideas

● **Verb snap:** Using the words from poster page 11, or selecting other verbs made by adding prefixes, create two sets of cards – one showing verbs and the other prefixes. Children then play in pairs and turn over one card on each pile at a time, shouting 'Snap' if the prefix and verb correctly form a new verb. Extra points might be awarded if they can explain the meaning of the word and/or the meaning of the prefix.

● **Rewrite:** Provide a selection of sentences using root words for the verbs, ensuring that each sentence has a verb that can take a prefix to change its meaning (the poster on page 11 can help with this). Then ask children to identify the verb, add an appropriate prefix to change its meaning and write a new sentence using the new verb in a correct context.

Digital content

On the digital component you will find:
- Printable versions of all three photocopiable pages.
- Answers for all three photocopiable pages.
- Interactive versions of all three photocopiable pages.

Verb prefixes

Prefix hunt

■ The passages below contain several verbs that have been made by adding prefixes to other verbs. Identify these verbs and then write them, showing the prefix separately, in the boxes below the passages. One word has already been identified.

Every spring the daffodils reappear. They co-exist on grassy banks with animals waking from their winter hibernation, unless they oversleep of course! Some birds, those that travel from far away, often revisit the same place every year, disappearing once again as the winter approaches.

If you are going to run a marathon you should not underestimate how difficult it can be. Even if you are a fast sprinter and can outrun your friends for short distances, being fit enough to run for hours on end takes months of training, and you should not undervalue the importance of a proper diet in improving your fitness. Some people are misinformed about this, and can overwork their muscles, which can be very painful.

re/appear		

Name:

Verb prefixes

Meaning matters

■ Create new verbs by matching the prefix to the verb. Then link these new verbs to their correct definition.

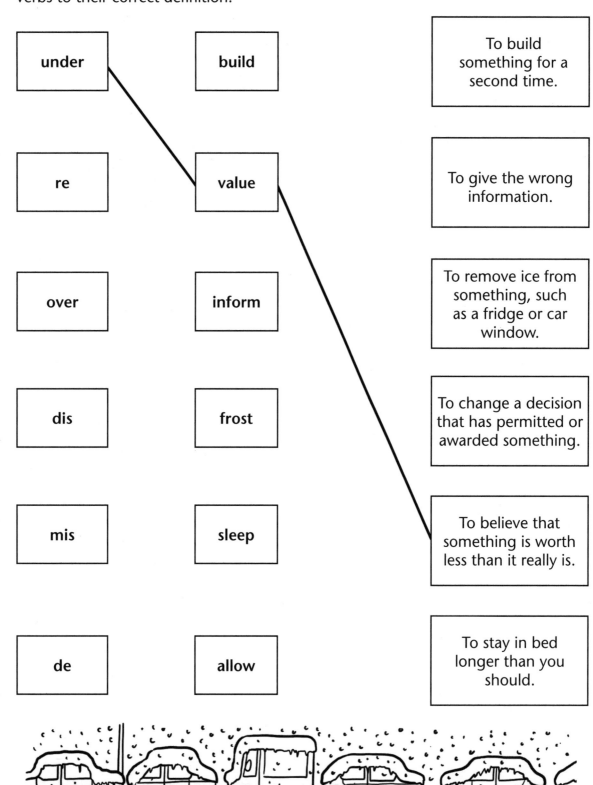

under	build	To build something for a second time.
re	value	To give the wrong information.
over	inform	To remove ice from something, such as a fridge or car window.
dis	frost	To change a decision that has permitted or awarded something.
mis	sleep	To believe that something is worth less than it really is.
de	allow	To stay in bed longer than you should.

PHOTOCOPIABLE

Verb prefixes

Constructing verbs

■ For each sentence below, add the missing prefix to the verb and then complete the sentence in your own words. Be sure that it makes sense.

1. After walking for two hours we _____turned to the same place because

2. The whole class started _____behaving as soon as _____

3. Hennaz _____charged her mobile then _____

4. John _____heard his mother talking to his teacher when _____

5. Although she _____covered from the accident she never _____

6. The goal was _____allowed because _____

■ Now can you make up some other sentences with missing verb prefixes to challenge your friends?

Expanding noun phrases

Objective

Use expanded noun phrases to convey information concisely.

Background knowledge

Although determiners and adjectives, among other words, are well-known modifiers of nouns, children may find it trickier to grasp that words that come after a noun can also be part of its modification, forming descriptive expressions that provide more information about the noun. For example, in the phrase *Her elderly cat with claws like razors*, all of the words modify the noun 'cat'. Through these words we find out that the cat has an owner, is old and has sharp claws – the phrases provide a lot of concise information about the cat.

Activities

● **Photocopiable page 25 'Modifying nouns'**
This activity aims to refresh and develop children's grammatical knowledge of nouns and how they are modified by adjectives and other words. In reviewing work with the class, you may wish to highlight and reinforce other word classes and rules for sentence construction.

● **Photocopiable page 26 'Build-a-phrase'**
This activity encourages children to create noun phrases of increasing complexity, allowing them to see that modifiers can be added before and/or after a noun. In reviewing work with the class, it is useful to focus in particular on how the same noun can be modified in quite different ways.

● **Photocopiable page 27 'Find the phrase'**
This activity provides a passage of text with a range of noun phrases in it for children to identify and discuss. It can be extended by challenging the children to rewrite the passage changing each noun phrase.

Further ideas

● **Word pictures:** Collect a range of pictures from magazines and newspapers and display them. Ask the class to write expanded noun phrases about two or three of these images each day. Their phrases can be literal (for example, *the old man in the red coat*) or imaginative (for example, *the elderly spy on a secret mission*). Volunteers can then read their expanded noun phrases and challenge each other to identify the image it refers to.

● **The magnificent expanding noun phrase:** Write a selection of nouns on pieces of card, and, working in groups of four to six, ask each group to select a noun. The children in each group must then take turns going round the group adding descriptive elements before or after the noun to gradually increase the amount it is modified. Children need to monitor carefully whether each addition is actually modifying the noun and therefore belongs to the noun phrase or not. Work as a class to share each others' phrases, discussing vocabulary choices and effectiveness.

● **Learn from the experts:** Several authors, such as Michael Morpurgo, seem to be able to convey impressions and stories quickly and effortlessly. Focus on a selection of their texts and consider how they use noun phrases – children may be surprised at the economy of the writing.

Digital content

On the digital component you will find:
● Printable versions of all three photocopiable pages.
● Answers to 'Find the phrase'.
● Interactive version of 'Find the phrase'.

Modifying nouns

We can spot a noun if it can take a determiner, like 'a' or 'the'. For example: horse – *a horse, the horse, his horse*, and so on. We say that the determiner 'modifies' the noun; it gives us more information about the noun.

We can create a noun phrase by modifying the noun with, for example, an adjective. For example: *the grey horse*. By adding the adjective 'grey' we have created a noun phrase.

By adding more words that are about the noun we create an *expanded noun phrase*, a group of words around a noun. For example: *She liked the grey horse with a bushy tail*. The noun is also modified by the words *with a bushy tail*, so we can say that *the grey horse with a bushy tail* is an expanded noun phrase.

■ Now it's your turn. Create expanded noun phrases for each of these nouns.

cat

house

car

book

Name:

Expanding noun phrases

Build-a-phrase

Nouns can tell us the main piece of information about things, such as 'cat', 'house' or 'book', but they need to be modified to give more accurate information. Look at the bold words and how they modify the underlined nouns.

She owned **a large, grey** <u>cat</u> **with a bushy, white tail.**

He lived in **the ramshackle, lop-sided** <u>house</u> **that creaked and groaned in the wind.**

It was **an extraordinary** <u>book</u> **that was full of strange words and ideas.**

■ Use the nouns, adjectives and expressions below to build interesting noun phrases. You can change or add words to help your work make sense.
For example: *It was a small, quiet cat that only came out at night.*

Adjectives	Nouns	Expressions
small	cat	that only came out at night.
large	house	who never washed during the week.
quiet	book	where everything seemed tinged with evil.
crazy	dog	that smelled of roses.
old	jewel	was made of stone.
cold	boy	from under the table.
lonely	girl	with eyes like large green pools.
young	teacher	that filled all who saw it with dread.
confused	horse	that glistened in the starlight.
rambling	town	with a cruel, twisted grin.
blue	message	which filled us with fear.
massive	mountain	who lived all alone.
filthy	coat	whose face was creased with laughter lines.
delightful	voice	of terrifying proportions.

Expanding noun phrases

Find the phrase

■ Circle the noun phrases in the passage below. The first one has been done for you.

Tommy was (a happy, playful dog). He had lived with Beth and her family for only a few months, but already felt at home in their shabby, old house. Monday began like any other school day: Beth woke Tommy to go for a walk. He loved his warm bed under the sofa, but he loved going to the park even more. It was a large grassy park that was surrounded by trees, perfect for running and playing.

As soon as they arrived, Beth took off Tommy's lead and he ran joyously across the cool, damp grass, full of daisies and buttercups. After a while he noticed another dog coming towards him, a fierce, growling dog with matted fur and old yellow eyes. Tommy sensed danger, and turned and looked for Beth. He recognised her blue jacket and her wild, frizzy hair that stood up like a wild bush on top of her head. He ran back to her with the other dog running fast and catching him up.

Beth knew what to do: she pulled out of her bag a large, smelly bone that the butcher had given her and threw it to the other dog. The bone had been a treat for Tommy, but his safety was more important. The fierce dog growled contentedly and started munching on the bone, and Beth and Tommy calmly headed for home.

After a start to the day like that, Tommy only had two things in mind: breakfast and bed. Beth treated him to an extra-large portion of dog biscuits, followed by six juicy sausages. He gulped it all down contentedly, drank some cool, fresh water, let out a great big yawn that was heard all around the house, and slipped quietly into his bed.

Making words work

Objective

Develop use of prefixes and suffixes, and experiment with word classes and expanded noun phrases to improve sentences.

Writing focus

Building on previous activities, this section encourages children to use and apply their knowledge of grammatical features and structures creatively.

Skills to writing

● **Words do things**

Maintain children's awareness of the simple fact that words do a job. When looking at a text, whether it's a shared read or a letter to take home from the head teacher, encourage children to review the different jobs each word is doing. Hand out colouring pencils and ask them to circle actions in red, things in green and to reflect on the jobs done by these verbs and nouns. Extend this to circle descriptive words in another colour and connecting words in another. In all this, keep asking: *What sort of job is that word doing?*

● **The story of the sentence**

Understanding that words perform a function for a sentence is a vital way of enabling young writers to reword lines. One way of developing this idea is to ask children what 'the story' is in each sentence. Ask: *What's happening?* Each sentence will have a clear 'story', and by asking this question children can express as much as they have understood of a complex string of words. Keep finding ways of telling that story in different ways – making a game of saying the same thing in a variety of ways.

● **Sentence craft**

Keep the sentence high on the list of priorities for children's thinking. It should be the focus for the crafting of texts, and provides a great way of experimenting with expressiveness.

● **Roots and branches**

When revising a single piece of work, ask the children to look for examples of where a root word has been changed throughout the text and to map the grammatical rules they have used to devise the variations. If, for example, they are writing about 'smell', they may use the plural to describe various 'smells', write how something 'smelled' or how certain things are 'smelly', perhaps listing all prefixes and suffixes used. Also, encourage them to use their own writing to investigate where and why they have adopted a range of rules.

● **Verbs galore**

Using higher-level texts from newspapers, reference books and websites, or fiction, challenge children to scan these and identify as many verbs as possible, for each verb writing as precise a meaning as possible. In particular, ask them to look for verbs that have prefixes and/or suffixes attached, and have them 'deconstruct' these words and identify the role of each affix.

● **Phrase detectives**

Identifying noun phrases in single sentences is relatively straightforward, but it becomes much more complex when considering them within whole texts. Remembering the basic rule that any word that, either alone or as part of a group, modifies the noun at its head is part of the phrase, examine different texts with the class to identify and discuss a wide range of such phrases.

Activities

● **Photocopiable page 30 'Verb magic'**

Children are presented with simple sentences. They must take the verb from each sentence and add a prefix to create a new verb and use it in a new sentence. This will strengthen their understanding of the meaning of the new verb. This work can be extended by creating sentences for all the verbs on poster page 11 'Using prefixes and suffixes to make verbs' (and indeed any others the children discover), and creating new sentences containing altered verbs.

● **Photocopiable page 31 'The ring'**

Children are presented with a bland piece of writing and a range of options for the style with which they might rewrite it. They must then improve it by adding complex noun phrases. In reviewing work, consider examples where children might have used too much modification, exploring how texts can appear stodgy and dull where excessive phrase development is used.

Write on

● **Random words**

Ask: *If I wrote five words on the whiteboard do you think you could use them all in one sentence?* So begins a challenge that has a hundred variations – all tasking children with forming and reshaping their writing. Ask: *If I wrote ten words… Could you make a sentence less than 25 words long? Could you make this sentence rhyme with the last one? Could you use the word 'supposition'? Could you write it quicker than the time it takes the rest of us to sing 'Mary had a little lamb'?* Children can respond verbally or in writing.

● **Twisted penguins**

Children write sentences on strips of paper along the lines of: *A/An* (noun) (verb) *a/an* (noun) (for example, *A runner twisted an ankle*). They could adopt the model of inserting adjectives and adverbs (*A big penguin foolishly lost a tasty fish*). Once the children have a few sentences they can cut out the various nouns, verbs and other word classes and use the piles of word types to generate random sentences, such as *A tasty runner foolishly twisted a big fish*. As they do this they need to catch and record the weirdest and funniest examples. This can also lead to an appreciation of the way certain words can take different roles – as when a verb like 'twisted' is used to describe athletes and penguins.

● **A book of verbs**

Create individual or class verb books, in particular highlighting those formed with affixes. In the books the verbs should be presented with all variations as below:
rewrite – to write something again
rewrite; rewrites; rewriting; rewrote; rewritten
For example: *I have rewritten my homework with more nouns modified and it is much better.*

● **Developing writing**

From time to time, ask the class to review their written work only with nouns in mind, challenging them to effectively modify them. It is important to note that this may include reducing the amount of modifiers as well as increasing them, and remind them that this is just as important for non-fiction as fiction.

Digital content

On the digital component you will find:
● Printable versions of both photocopiable pages.
● Answers to 'Verb magic'.
● Interactive version of 'Verb magic'.

Name:

Making words work

Verb magic

■ Verbs can have their meaning changed by adding prefixes to them. In each sentence below, identify one verb (or more) that can be modified, and change it using an appropriate prefix.

■ Then create a sentence for the new verb below the original.

Example: The rabbit **appeared** out of nowhere.

New: All of a sudden the man **disappeared** behind a wall.

Possible prefixes: over, un, re, mis, under, dis, de

1. Please fasten your seat belts.

New: _____

2. Please select the jumper you want to wear.

New: _____

3. There are so many children – we need to build another classroom!

New: _____

4. Jenny estimated that the pumpkin was ten kilos.

New: _____

5. I have finished my dinner.

New: _____

6. Shhh! Peter slept during the day because he worked all night.

New: _____

PHOTOCOPIABLE **SCHOLASTIC**
www.scholastic.co.uk

Making words work

The ring

■ The text below has been written very simply, with nouns identified in bold. Circle the genre you want to use, and rewrite the text adding expanded noun phrases to modify the nouns and improve the text. You can also complete the story with your own ending – remember to keep using noun phrases to improve your descriptions!

The ring

The **house** was on a **hill**. A **boy** went inside. He saw a **table** with a **box** on it. He opened the **box**. Inside was a **ring**. He put on the **ring** and left the **house**. He walked down the **hill** and into the **town**. He went straight to his **school**…

Circle the genre you want to write in.

COMEDY science fiction FANTASY HORROR Thriller MYSTERY

Chapter 2

Adjectives and prepositions

Introduction

This chapter revisits two word classes that children will have previously encountered, extending their understanding and use of adjectives and prepositions to extend their vocabulary and develop their sentence writing, leading to more descriptive and flowing writing via a range of tasks.

Adjectives are explained as words that modify nouns or complement verbs, and adjectival phrases are introduced. Prepositions are developed as words that link nouns to convey information on place and time. For further practice, please see the 'Adjectives and prepositions' section of the Year 5 workbook.

In this chapter

Adjectives page 35	Revisit and consolidate understanding of adjectives.
Using adjectives page 39	Extend the use of adjectives in writing.
Prepositions page 43	Understand the function of and identify prepositions.
Using prepositions page 47	Use prepositions in writing.
Developing adjectives and prepositions page 51	Select adjectives carefully to improve writing, and develop the use and range of prepositions.

Poster notes

Adjectives (page 33)
This poster contains drawings of three invented creatures. Use it to develop vocabulary, via thesaurus use if desired, as well as providing prompts for writing, poetry and oral word games.

Prepositions (page 34)
This poster provides a selection of common prepositions. Display it in the classroom and use as a reference or prompt for writing tasks.

Vocabulary

Children should already know:
adjective, preposition, phrase
In Year 5 children need to know:
adjectival phrase

Adjectives and prepositions

ADJECTIVES

What words can you use to describe these creatures?

Adjectives and prepositions

Prepositions

towards

in front of

under

through

for

except for

behind

before

while

into

since

instead of

because of

between

out of

ABOUT

across

away from

after

against

Adjectives

Objective

Revisit and consolidate understanding of adjectives.

Background knowledge

An adjective is a word that modifies a noun. Among other things, it can describe the shape, size or appearance of a noun. Adjectives can also be used after a verb as its complement.

More than one adjective can be used at a time, although adjectives never modify other adjectives. For example:

A square box.

The box is big. (Here the adjective is a complement.)

A scruffy, blue box.

Activities

● **Photocopiable page 36 'Find the adjectives in...'**
Use this activity as a starting point for finding adjectives in a range of texts. Ask the children to use the adjectives in their own sentences.

● **Photocopiable page 37 'Choose your adjective'**
As a way of revising the use of adjectives, this activity asks the children to link adjectives to nouns. They can experiment with various combinations, producing unusual and interesting results. Ask children to consider which combinations strike them as unacceptable (and why). How many of the adjectives sit comfortably before the nouns and can be used in a coherent sentence? To extend this activity consider adjectives as complements to verbs, such as *The night was cold*.

● **Photocopiable page 38 'Adjective links'**
This activity encourages children to look at the variety of adjectives that can be linked to a particular context. The easiest way for the children to carry it out is to start with one adjective, link it to a noun and then find other words that can be substituted for their initial adjective. This can be extended with the use of a thesaurus to help build vocabulary.

Further ideas

● **Adjectives in pictures:** Looking at pictures, whether photos from magazines or paintings in a gallery, children identify items and think of the adjective they would use to describe them, forming sentences and challenging peers to identify items from their statements. This could be extended to using adjectives as complements, for example *She is confident*.

● **Selling properties:** Children can produce their own estate-agent leaflet or holiday brochure. They could try describing their own house or make a leaflet for the sale of the school. They could produce a promotional paragraph describing the locality, for example.

● **An adjective beginning with...:** To play this game, the children will need ten cards with ten different letters written on them. Shuffle the cards and place them in a pile, face down. Then say: *Think of an adjective that describes…*, inserting a noun. It could be a place, a famous person, a television programme, an event in school – any appropriate noun. Having said this, add *beginning with* and turn over the first card to show its letter. The children then have to come up with an adjective beginning with the letter on the card as quickly as they can.

Digital content

On the digital component you will find:
● Printable versions of all three photocopiable pages.
● Answers to 'Find the adjectives in...'.
● Interactive version of 'Find the adjectives in...'.

Name:

Adjectives

Find the adjectives in…

■ Look at these quotes from different texts. Circle the words or phrases that are adjectives.

 This spacious house is situated on a charming, quiet road.
(Estate agent mailing)

 On top of a windy hill with nothing else to be friends with lived Something Else
(*Something Else* by Kathryn Cave)

 I took Dad's watch to pieces.
Mum said that I could.
I love these shiny wheels and things...
(*The Watch Mender* by Michael Glover)

 'Is there anybody there?' said the Traveller,
Knocking on the moonlit door
(*'The Listeners' by Walter de la Mare*)

 Moist tender coconut covered in thick milk chocolate.
('Bounty' advert)

 Torrential rains have caused a flood alert across the region.
(Local paper)

 He receives comfort like cold porridge.
(*The Tempest* by William Shakespeare)

 Don't miss this new series of scary stories.

 Thank you for the fantastic present. It was a brilliant surprise.

■ Write some new sentences using the same adjectives on the back of this sheet?

Adjectives

Choose your adjective

Here's a pile of adjectives:

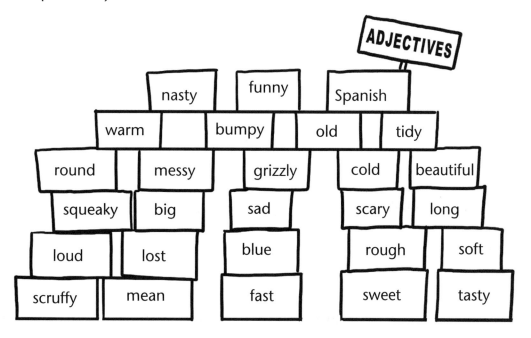

and here's a pile of nouns:

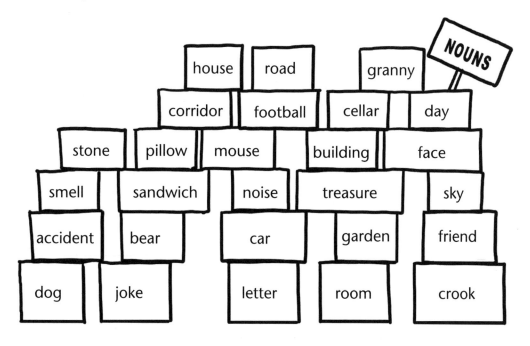

■ Combine 20 of the nouns with suitable adjectives. Write them down on a separate sheet of paper. For example:

messy house

SCHOLASTIC
www.scholastic.co.uk PHOTOCOPIABLE Scholastic English Skills
Grammar and punctuation: Year 5 37

Name:

Adjectives

Adjective links

■ Collect together similar sets of adjectives. Try to get **five** or more adjectives in each set. For example:

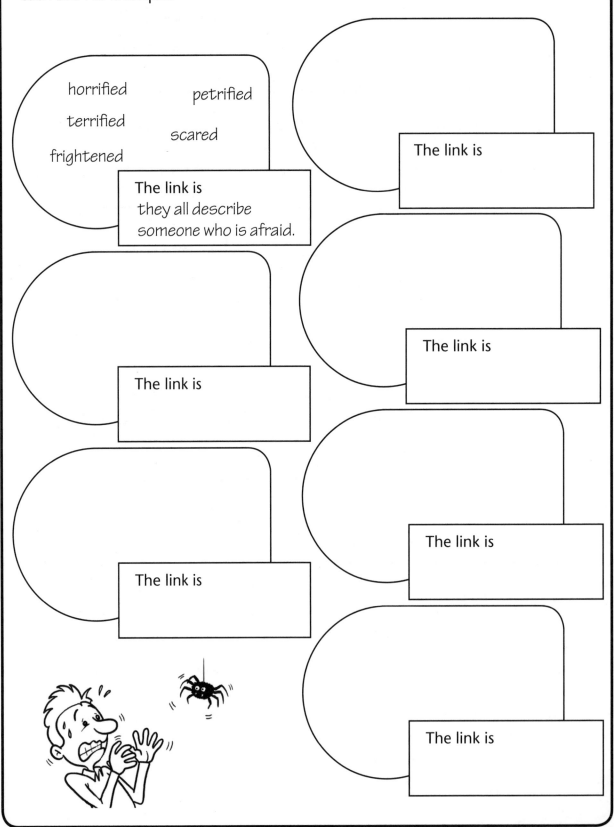

horrified petrified

terrified scared

frightened

The link is
they all describe
someone who is afraid.

The link is

The link is

The link is

The link is

The link is

The link is

Using adjectives

Objective

Extend the use of adjectives in writing.

Background knowledge

Adjectives have links with other adjectives, and some of them are more extreme than others. A key factor in choosing appropriate adjectives concerns their 'intensity'. If someone spills a drop of tea on the tablecloth they may say, *Oh, that's annoying*, but they would be exaggerating if they deemed it *completely disastrous*.

Nouns can also be modified by adjectival phrases. These are groups of words that describe a noun:
A perfectly square box.
The box is bigger than the ball.
A box as scruffy as me.

Activities

● **Photocopiable page 40 'Your intensity scale'**
The intensity of adjectives used to describe something like a spider will vary according to the person making the description. This activity asks the children to explore the varying intensity of their responses to different things. They can use their completed photocopiable page 38 'Adjective links' to provide material for it.

● **Photocopiable page 41 'Adjectival phrases'**
The task in this activity is to isolate the string of words that is acting as an adjectival phrase and to identify the noun it describes. Explain that the question *What is being described?* underpins the process of finding the adjectival phrase.

● **Photocopiable page 42 'Boasts'**
Ask the children to read the boasts and to try to write their own. Encourage them to consider the most extreme ways in which the quality they have chosen could manifest itself. They could then perform an enactment of their boasts as a drama activity.

Further ideas

● **'Hot and cold':** Adapt the old game in which people would hide something in a room and, as someone else looked for it, guide them as to how close they were by saying 'Cold… cool… warmer…'. The game relied upon variable temperature as a guide to how close the seeker was to the hidden object. The same game can be played using other scales of intensity, such as those used for happiness and sadness, or fear and confidence.

● **Compare the scale:** Ask the children to reuse their completed copies of photocopiable page 40 'Your intensity scale', and to write the nouns on one set of cards and the adjectives on another. Invite them to challenge their classmates to join the words, recording their results. Are particular cards that are always chosen as a matching set evoking the same response? Discuss outcomes and consider effective usage.

● **Making blurbs:** Provide the children with a current review of a particular children's book taken from a newspaper or a magazine and ask them to highlight the adjectives in it. Next, they must choose a snippet of text containing at least one adjective which they would print on the back of the book if they were marketing it.

Digital content

On the digital component you will find:
● Printable versions of all three photocopiable pages.
● Answers to 'Adjectival phrases'.
● Interactive version of 'Adjectival phrases'.

Name:

Using adjectives

Your intensity scale

■ Each row shows two adjectives. They move from the less intense to the more intense.

■ Think of something you would describe using the two different words.

Noun	Adjective 1	Adjective 2
_____	good	brilliant
_____	warm	hot
_____	tasty	delicious
_____	smooth	slippery
_____	smelly	stinking
_____	simple	easy peasy
_____	scary	terrifying
_____	quiet	silent
_____	cold	freezing

■ Now see if you can make up your own examples.

Noun	Adjective 1	Adjective 2
_____	_____	_____
_____	_____	_____
_____	_____	_____
_____	_____	_____

Using adjectives

Adjectival phrases

An adjectival phrase is a string of words that describes a noun.

| School is | totally brilliant. |

Adjectival phrases stand in place of single adjectives.

| School is brilliant. |

Adjectival phrases contain an adjective.

| School is | totally **brilliant**. |

■ Look at the text in the speech bubbles. In each one find the string of words that is describing the noun. Underline the string of words. Circle the noun being described.

This picnic is more than enough.

My brother has grown to be bigger than me.

She gave me the sweetest, loveliest, dreamiest smile.

The long and winding road leads to the house.

The letter must be lost in the post.

The weather today is hotter than July.

Nothing beats sailing the big, bright, blue sea.

This football is flat as a pancake.

Name:

Using adjectives

Boasts

Here are some boasts collected from various people and places:

I know someone
who can run so fast
he meets himself
coming back.

I know someone who's
so good at jumping
she can jump across a
river and back without
touching the other side.

There's a man round here
who is so tall
he has to climb a ladder to shave himself
when he was born he was so big
it was impossible to name all of him at once
he grew so fast
his head grew three inches through the top of
his hat.

Each one boasts about an adjective:

so fast so good at jumping so tall so big

■ Try making up your own incredible boasts. Start with:

I know someone who is so…

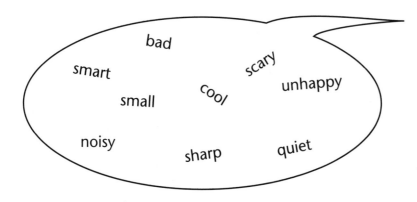

bad

smart

scary

cool

unhappy

small

noisy

sharp

quiet

SCHOLASTIC
www.scholastic.co.uk

Prepositions

Objective

Understand the function of and identify prepositions.

Background knowledge

Prepositions link nouns, pronouns or noun phrases to other words in a sentence, usually indicating when or where something is in relation to something else. They tend to be short words, and are limited in number. Prepositions can consist of one word (such as 'over', 'at' and 'before') or two words (such as 'out of' and 'away from'). There are also complex prepositions that are made up of three words (such as 'in front of' and 'on top of').

Prepositions are position words that come before other words. In a sentence like *The cow jumped over the moon* the preposition 'over' explains where the cow jumped in relation to the moon (as opposed to 'under' or 'through' it). They can also show relationships of time, such as 'before' and 'after'. Prepositions can also indicate possession (*The house of my uncle*) or they can show other links between nouns (*I want coffee instead of tea*).

Activities

● **Photocopiable page 44 'Listing prepositions'**
This activity asks children to list all the prepositions they can think of. As they do this, you may wish to let them look in various texts such as story books, newspapers and instruction leaflets in order to find examples.

● **Photocopiable page 45 'Find the prepositions'**
Looking at the text, ask the children to find the prepositions. Remind them that prepositions are about more than just place – they can indicate time as well.

● **Photocopiable page 46 'Preposition spaces'**
This cloze activity requires children to examine the context of a story in order to decide which preposition best fits each of the newspaper articles.

Further ideas

● **The exhaustive guide:** The class can turn their own efforts at preposition recognition into a whole-class list to which they all contribute.
● **Big pictures:** Try and obtain a large picture in which a lot is taking place, such as a modern cartoon poster or a print of a classic picture (Pieter Brueghel's *Children's Games* is good for this). Ask the children to point out things and notice how they use prepositions.
● **Directions:** Make a recording of an adult giving directions. Replay the recording and ask the class to spot and note the prepositions used. Ask: *Which ones are the most common?*

Digital content

On the digital component you will find:
● Printable versions of all three photocopiable pages.
● Answers to 'Find the prepositions'.
● Interactive version of 'Find the prepositions'.

Name:

Listing prepositions

Prepositions are words that can show the link between two things.

* They could be linked in time for example:

I had breakfast before school.

* or space

Put the jigsaw in the box.

* or in another way

This cake is for Gran.

■ How many prepositions can you think of? Write them down on a separate sheet of paper.

Prepositions

Find the prepositions

■ Can you find the prepositions in these directions? Circle them.

Travel by boat up the river towards the windmill. Stop beside the windmill and walk behind it. Walk across the field into the wood. Carefully pass through the wood until you see the arch. Before going through the archway check you are not being followed. Go under the arch and through the tunnel. You will come out by the old oak tree. After reaching the oak tree walk down the hill and over the stream. Near the stream you will see a house on a hill. Go to the door, the key is under the mat, and step inside...

Name:

Prepositions

Preposition spaces

■ Look at the newspaper articles below. Prepositions have been removed from the texts. Can you think of a word that would fit each of the spaces? Remember, prepositions can be one or two words or more.

Hands _____ the water

_____ weeks _____ preparation, Martina Hands, a teacher _____ Balstone Junior, is ready _____ a challenging ordeal. Martina plans to sail _____ the English Channel _____ a home-made raft. The raft is made _____ recycled materials and has been trialled _____ all types of water, _____ the Channel. This Saturday, raft and Channel meet for the first time, battling _____ themselves to see who will win. Martina is confident the raft will hold _____ wind and rain. She will be protected _____ a tarpaulin but says she will still wrap up well.

Martina has always been a keen sailor. _____ teaching she was _____ the navy. She said "I've been _____ difficult journeys and am looking forward _____ this one. But I hope I'm not _____ school for too long."

Boxing match

Fruit seller, Carl Hall, is furious _____ council plans to stop his long-standing practice of stacking fruit boxes _____ his shop. Council officials say his boxes are obstructing the pavement, where they are arranged. "I am furious," said Carl. "I have displayed goods _____ the canopy _____ my shop _____ years and _____ this I have never had any complaints." Pointing to the pavement he says "There is plenty of room _____ boxes and the road. I can't see what all the fuss is _____."

Council spokesperson said "Mr Hall has ample room to display goods _____ his shop window. We don't want a fuss _____ a couple of boxes." But Carl plans to appeal _____ the council's decision.

Using prepositions

Objective

Use prepositions in writing.

Background knowledge

Children may have already been introduced to prepositions as a way of joining phrases (along with conjunctions and adverbs). Although this can be quite complex to understand, teachers may wish to reinforce this use while focusing on prepositions. As well as indicating relationships of time and space, prepositions are an essential element for crafting flowing sentences. As such, their varied and selective use is an important aspect in developing children's writing, and looking at texts that show prepositions in complex sentences fulfilling a range of functions will be useful at this stage.

Activities

● **Photocopiable page 48 'Preposition picture'**
The picture prompts children to root out some of the prepositions they already know and to use them in sentences. Children could try the same activity with other pictures.

● **Photocopiable page 49 'Using prepositions'**
This activity asks children to produce sentences that use a range of prepositions. It can be made more challenging by suggesting to children that, as they write their sentences, they may include another preposition not shown on the photocopiable sheet.

● **Photocopiable page 50 'Pop'**
Using Michael Rosen's poem 'Busy Day' as a guide to preposition use, children can use various imperatives to produce their own poem in a similar vein.

Further ideas

● **Comic stories:** Looking at three pictures from a comic story, ask the children to write sentences about the scenes using a variety of prepositions. Remind them that they can write using time prepositions (such as 'before', 'after') as well as spatial ones (such as 'over', 'through').
● **Preposition cards:** Write some prepositions on a set of ten cards. Ask children to place the cards face down and take turns at removing three cards from the pile and making a sentence with whichever words they select. This can be used to focus on different preposition types.
● **Preposition time:** There are a wide selection of prepositions of time (such as 'before', 'during', 'after', 'while', 'since', 'for', 'around', 'until'). Challenge the class to write a short story about an event, such as a football match, that includes each of these time prepositions once.
● **'in', 'on', 'at':** Provide suitable texts and ask the children to identify rules for when each of these three prepositions is used. Why do we say *in the morning, at three o'clock*, and *on Friday night*?

Digital content

On the digital component you will find:
● Printable versions of all three photocopiable pages.

Name:

Using prepositions

Preposition picture

■ Look at this picture and write some sentences about it.
■ Try using these words in your sentences.

up	into	out of	away from	between
across	in front of	about	through	against
after	towards	down	behind	under

Using prepositions

Using prepositions

■ Write sentences in the spaces provided, using both of the prepositions.

instead of into	Instead of just standing beside it, we jumped into the pool.
except for about	
away from between	
across because of	
in front of before	
through after	
against since	
towards out of	
while behind	
under for	

Name:

Using prepositions

Pop

■ Read this poem by Michael Rosen.
■ Notice how many different prepositions are used. Could you write a similar poem, using a range of prepositions after a verb?

Busy Day

Pop in
pop out
pop over the road
pop out for a walk
pop in for a talk
pop down to the shop
can't stop
got to pop

got to pop?

pop where?
pop what?

well
I've got to
pop round
pop up
pop in to town
pop out and see
pop in for tea
pop down to the shop
can't stop
got to pop

got to pop?

pop where?
pop what?

well
I've got to
pop in
pop out
pop over the road
pop out for a walk
pop in for a talk…

by Michael Rosen

Developing adjectives and prepositions

Objectives

Select adjectives carefully to improve writing, and develop the use and range of prepositions.

Writing focus

Building on previous activities, this section encourages a focus on the use of adjectives for particular purposes, and on the functions of prepositions in relation to the real texts children create.

Skills to writing

● **Non-fiction texts**

Adjectives also have a useful role to play in the planning and writing of factual and report texts. Children will often write the bare facts in these texts, and one way of enriching these is to ask them to read through each others' drafts, checking to see whether they can effectively envisage the subject matter. Ask: *Is there a need for more description that will make things more visible to the reader?*

● **Persuasive adjectives**

Adjectives have a different role to play in persuasive speaking and writing. Whereas a report text will generally aim for a neutral description of a subject, persuasion is trying to influence the reader. As a result, advertisements, letters to the newspaper, protest leaflets and so on, will usually include stronger descriptions of whatever they are promoting and sometimes derogatory descriptions of the alternative. Studying a selection of these can make for interesting debates as well as strong learning.

● **Phrases**

Gather adjectival phrases. It's surprising how common these are – but given the inclusion of similes, imagery and qualified adjectives (like *utterly disgusting*), the list ends up being quite extensive and containing some of the best examples children will want to use.

● **Synonym sorting**

Synonyms can be introduced through adjectives. Collect alternatives for basic adjectives like 'good' and 'bad', using a thesaurus if desired. The children are not expected to know the term 'synonym' until Year 6, but you may wish to introduce it to them here.

● **When and where**

Look out for the use of prepositions in texts. On locating them, look at the questions they answer about 'when' and 'where'. The first sentence in this paragraph uses the preposition 'in', to answer the question *Where are the prepositions?* As they examine these uses, draw children's attention to the additional touch of detail that is usually provided, linked to the preposition.

● **Report and news writing**

Prepositions can provide a way of teasing out the details that surround reports and news stories – particularly if children are writing a recount about an event they were involved in. As any teacher who has had to solve a conflict can tell us, the issue of who did what when, and who started it, is vital. Children can use the prepositions on poster page 34 'Prepositions' to tease out details of their reports, expanding on the question of what happened, and where and when the various details fall.

Activities

● **Photocopiable page 53 'In your own words'**

This activity involves children looking at pieces of their own writing. As preparation, you may want to select pieces of writing that would best be applied to this activity and have either word banks or thesauruses available. Give children time to discuss their word choices and then revise their work.

● **Photocopiable page 54 'Fantasy land'**

Using the map on the photocopiable sheet, children can produce a set of directions for the visitor to this fantasy land. Ask: *What locations will they have to pass through, skirt around and fly over (and how will they make these journeys)?* Once they have written up the text, they could try producing it in an antiquated font on parchment-like paper. This could also generate a story that includes the journey.

Write on

● **Back cover quotes**

Using a wide selection of books, examine the quotes that often appear on the back covers, for example: *A truly delightful story... warmly recommended*. Collect a bank of effective adjectives and adjectival phrases that can be displayed and reused in the children's own reviews.

● **Thingy stories**

Draw a strange blob with eyes on the whiteboard and write next to it: *This is a Thingy. It is a big, warty, squeaky, spotted, smelly Thingy*. Discuss this and consider its personality and so on. Is there a single adjective that might define it? The class might then work in groups to create a family, class or community of Thingies and devise stories about them. Encourage them to draw on the qualities they have described – so if one Thingy is lazy, let that be a part of their role in the story.

● **Advert writing**

Write and perform adverts as if the classroom was a television studio. Look at some current adverts for hair products, chocolates, drinks and so on, and ask the children to work in groups to devise their own suggestions for advert scripts. Encourage them to focus on the use of interesting adjectives to describe products. One important feature of this activity is to have a point on the wall that acts as the camera allowing children to talk with confidence to the viewers.

● **Rosie's journey**

Taking *Rosie's Walk* by Pat Hutchins (Red Fox) as their inspiration, children can devise their own story in which a character takes an interesting journey across, through and around various obstacles. They may also want to include a pursuer like Rosie's fox. This could provide stimulation for an illustrated text that children can then share with younger classes.

● **One moment**

A number of stories are made up of the coming together of characters who have complex interactions in the past, sometimes interweaving one character's storyline with another. Good examples include *Holes* by Louis Sachar (Bloomsbury) and *The Invention of Hugo Cabret* by Brian Selznick (Scholastic Children's Books). Children could plan out their own complex story in which various

characters all come together at one particular moment – like a lift getting stuck or a group of people trapped by rising flood waters. Ask: *What happened before, after and during the different events that have led each character to be here?* Children could work in groups of four constructing such a scenario, creating timelines for each character.

● **Clues**

Ask children to devise a treasure trail that could be set around school. What clues would they write? Would the next clue be on or under something? Would the next clue be taped in front of or beneath something? Challenge them to use as many prepositions in their clue trail as they can.

Digital content

On the digital component you will find:
● Printable versions of both photocopiable pages.

In your own words

■ Look at some pieces of writing you have done. Find some sentences that could have contained adjectives. Write the sentences in the first column.

■ Write each sentence again. This time, put in any adjectives that will make a better sentence.

Original	Redraft

Name:

Fantasy land

- Plan a route around and across the map, seeing what story ideas it generates.
- Produce a set of directions to help find the seven keys.

PHOTOCOPIABLE **SCHOLASTIC**
www.scholastic.co.uk

Chapter 3

Verbs and verb tenses

Introduction

This chapter develops children's understanding of verbs through a focus on understanding subject–verb agreement and using tenses correctly, moving on to modal verbs and their construction and use in children's writing. For further practice, please see the 'Verbs and verb tenses' section of the Year 5 workbook.

Poster notes

Verb-wise (page 56)
This poster provides a review of a regular and irregular verb in the present and past tenses, explaining and demonstrating how they are affected by their subject. Use it to good effect by displaying the poster on the whiteboard as an introduction to lessons focusing on this area of grammar.

The modal verbs (page 57)
This plain list of the modal verbs will assist children to recognise the basic list of the ones used in English. It will particularly support work in sections three and four. Display this poster in the classroom and remind the class that these verbs are always added to other verbs, and never take suffixes, although they do take 'not' in its full or contracted form, such as *We couldn't see the house.*

In this chapter

Making sure the verb agrees page 58	Use correct subject and verb agreement when using singular and plural.
Checking verb tense in writing page 62	Use correct tense and ensure consistent use of tense throughout writing.
What is a modal verb? page 66	Identify modal verbs and understand their function in a sentence.
Writing with modal verbs and adverbs page 70	Use modal verbs and adverbs to express possibility in writing.
Verbs in writing page 74	Use verb forms and verb tenses accurately in writing, and use verbs and adverbs to indicate degrees of possibility.

Vocabulary

Children should already know:
adverb, verb, tense (past, present, perfect)
In Year 5 children need to know:
modal verb

Verbs and verb tenses

Verb-wise

Verbs can be regular, such as the verb 'to like'; or irregular, such as the verb 'to be'.
Verbs can change in several ways.

Who or what?

Who or what are you talking about?
Is it singular or plural?

When?

Are you talking about the past, present or future?

Who	Present		Past	
I	like	am	liked	was
you	like	are	liked	were
she/he/it	likes	is	liked	was
we	like	are	liked	were
you	like	are	liked	were
they	like	are	liked	were

The 'subject' (who or what) determines the 'form' of the verb.
We must always check that the subject and the verb 'agree', in any tense.
Look at the examples below.

subject verb

Anne likes books.

subject verb

I am so happy.

subject

Stuart, although he was quite grumpy, liked dogs.

verb

subject verb

Joe and Rob were very sad yesterday.

When checking your work be sure to look at verbs.
Do you have 'subject–verb agreement', and have you got the tense right?

Verbs and verb tenses

The modal verbs

would	might	must	ought	should
Modal verbs The verbs shown on this poster are called modal verbs. These express such things as possibility, probability, permission and obligation. Modal verbs are used to change the meaning of other verbs. Modal verbs cannot be changed.				**Notes** Adverbs can also express probability, such as: 'certainly', 'definitely', 'undoubtedly', 'maybe', 'perhaps', 'possibly', 'probably', 'surely', 'unlikely'.
may	will	shall	can	could

Making sure the verb agrees

Objective

Use correct subject and verb agreement when using singular and plural.

Background knowledge

Although variation in verbs is somewhat limited in English compared to some other languages, children need to understand how verbs must always agree with their subject; the subject determines the 'form' of the verb. This involves the variation in the verb according to subject (for example 'I', 'you', 'she/he/it'; 'we', 'you', 'them'), as well as its behaviour when using modal verbs.

Introducing the word 'subject' to children at this stage can be tricky and children don't need to be introduced to this term until Year 6, but it may be useful to refer to it in this context. The main thing to point out is that it is usually a noun or a pronoun. (It can of course be a noun phrase, but this may complicate matters too much at the moment.)

Activities

● **Photocopiable page 59 'Timothy!'**
Ask the children to complete the cloze activity that requires the insertion of a range of verbs into a short passage of text. They need to ensure that the verbs make sense in context and agree with their subjects.
● **Photocopiable page 60 'Make the change'**
This activity provides simple sentences, each one written twice except that the subject has changed and the verb is missing from the second version. Children must complete the cloze activity by altering the verbs to match their new subjects.
● **Photocopiable page 61 'Switching subjects'**
This activity provides practice and consolidation for children in thinking about subject–verb agreement for simple verbs. Referring to poster page 56 'Verb-wise' may help consolidate the simple rules involved. You

might extend this activity by rewriting verbs in their past-tense forms and considering the effect on subject changes, though it may be preferable to do this after the next section.

Further ideas

● **How would the text change?:** Looking at various texts, ask children to work in pairs and to change the subject, perhaps into the first person, ensuring subject–verb agreement.
● **SV highlights:** To help encourage children to understand the grammar of subject–verb agreement and to use the terminology, ask them to scan a range of texts and in each sentence to highlight a verb and its subject in the same colour to show agreement. This can be effective using children's own texts (see next idea) as well as published texts, where it is likely that sentence constructions will be increasingly complex and may well have subjects and verbs separated by other words or phrases.
● **Self-review checklist:** All teachers ask children to review their own work, and it is sometimes useful to have checklists available. This can include checking for subject–verb agreement, especially for irregular verbs.
● **To be or not to be:** Repeat some of the activities and ideas above focusing solely on the verb 'to be', which is irregular in both the present and the past tense ('am', 'are', 'is'; 'was', 'were', 'was'). This is particularly important given this verb's role in the present continuous tense.

Digital content

On the digital component you will find:
● Printable versions of all three photocopiable pages.
● Answers for all three photocopiable pages.
● Interactive versions of 'Timothy!' and 'Make the change'.

Making sure the verb agrees

Timothy!

■ Insert a verb in each space in the passage below. Whatever verb you choose it must make sense, and you must make sure it agrees with its subject (who or what the sentence is about). All of the verbs have been written at the bottom of the page, but they may need to be altered to agree with their subjects.

Timothy _____ pizza but he _____ vegetables. If

you _____ him food he does not like he just _____ .

His family _____ he is a nuisance. He is always getting into

trouble. Sometimes he _____ the dog and sometimes he

_____ the cat.

If you _____ Timothy crawling towards you, beware; you

should _____ away as fast as you can and _____

somewhere safe. I should know: I _____ a scar on my right

knee, and his sister _____ tooth marks on her toes. Timothy

_____ sharp teeth and he _____ to use them!

have	hate	give	have	think	bite	run
lick	see	hide	like	have	scream	like

Name:

Making sure the verb agrees

Make the change

■ Fill in the spaces in each table.
■ Change the verbs to match the new subjects (who or what the sentence is about).

Every day I make my sandwiches.	Every day she _____ her sandwiches.
I only laugh at jokes if they are funny.	My brother only _____ at jokes if they are funny.
I have to do my homework now.	She _____ to do her homework now.
At the weekend I do some cleaning.	At the weekend he _____ some cleaning.
On Fridays I go to science club.	On Fridays she _____ to science club.
If I lose something I usually find it behind my bed.	If he _____ something he usually _____ it behind his bed.
I like to read comics.	He _____ to read comics.
I am brilliant!	She _____ brilliant!

■ Change the verbs to match the new subjects.

We always make our own sandwiches.	Pete always _____ his own sandwiches.
Robert laughs at jokes if they are funny.	We all _____ at jokes if they are funny.
David and Boris eat broccoli every day!	Tina _____ broccoli every day!
They are going on holiday tomorrow.	Timothy _____ going on holiday tomorrow.
On Fridays Joe and Tina go to science club.	On Fridays Hannah _____ to science club.
I like vegetables.	The dog _____ vegetables.
You all have to do your homework now.	Sandra _____ to do her homework now.
It is such a bright star!	The stars _____ all so bright.

Making sure the verb agrees

Switching subjects

Verbs must match their subject (who or what the sentence is about). They can be written in the first, second or third person, and in singular or plural.

First-person ver	Haydn 2015	
Second-person verbs		
Third-person v	He, She, They, It	

- Rewrite the sentences in the spaces below.
- Change any sentences written in the first person to the second person.
- Change any sentences written in the second person to the third person.
- Change and sentences written in the third person to the first person.
- Make sure your subjects and verbs agree.

I am going to school. _____

You play the piano. _____

He shouts his name. _____

They support united. _____

You draw brilliant pictures. _____

She says the alphabet quickly. _____

You were singing. _____

We climbed the rope. _____

They play in the park. _____

We are all alone. _____

SCHOLASTIC
www.scholastic.co.uk **PHOTOCOPIABLE** **Scholastic English Skills**
Grammar and punctuation: Year 5 **61**

Checking verb tense in writing

Objective

Use correct tense and ensure consistent use of tense throughout writing.

Background knowledge

Although children will use many verb forms in their speech, they will not necessarily understand the grammatical rules behind tense choices, and may have difficulty selecting tenses for appropriate effect in their writing. By this stage they should be aware of past, present, continuous and perfect tenses. As such, the focus of this section is not to teach tenses, but to help children become more skilled in spotting and using consistent tenses throughout written pieces. (Remember there's no future tense in English, future time is discussed by using the present tense and an infinitive.)

Activities

● **Photocopiable page 63 'Past, present or future'**
This photocopiable sheet provides basic consolidation of children's understanding of time. It provides a selection of verbs, each in short sentences which are jumbled around the page. Children have to sort these into order. The activity provides many starting points for discussing the use of tenses for meaning (for example, the present continuous versus the past) as well as encouraging thought about regular and irregular past participles and so on.

● **Photocopiable page 64 'Get it right'**
Children are presented with three passages of writing (about the past, present and future) and must insert verbs into each one so that the meaning is consistent and appropriate throughout. All of these texts can be used as starting points for further research and writing about the themes developed.

● **Photocopiable page 65 'Know your time'**
This sheet provides an overview, with examples, of different times. It is too much to expect children to grasp all the nuances and grammar of these, but they can be encouraged to develop awareness, particularly in looking at texts and identifying uses, while also noticing the auxiliary verbs and subject–verb agreement in all cases.

Further ideas

● **Verb spotting:** When reviewing texts with children, occasionally ask them to highlight any verbs they can find and write down the tense for each verb. Doing this regularly will improve children's use of grammatical terms as well as strengthening their knowledge of tenses.

● **Straight talking:** This exercise can be done in groups, and can be oral or written. Prompting groups to ask questions based on the past, present and future, choose one member to answer questions, and ask the rest of the group to pose questions to them that must be answered appropriately, always using the correct tenses. For example: *What did you eat for breakfast? Who is your favourite teacher? Where are you going after school?* More confident learners can be grouped and challenged to use all the tenses, using photocopiable page 65 'Know your time' as a support sheet if necessary.

Digital content

On the digital component you will find:
● Printable versions of all three photocopiable pages.
● Answers to 'Past, present or future' and 'Get it right'.
● Interactive versions of 'Past, present or future' and 'Get it right'.

Checking verb tense in writing

Past, present or future

■ Cut out these sentences and sort them into:
- ones that happen in the present
- ones that happened in the past
- ones that will happen in the future.

■ What do you notice about the different words in each group?

We had been watching television for hours.	
I play football a lot.	He tidies his room once a week.
I am going to play football tomorrow.	Dad had made cakes for the party.
He will tidy his room tomorrow.	Dad is going to make a cake for you.
I swim once a week.	We will watch television tomorrow morning.
Dad makes excellent cakes.	He is going to tidy his room after tea.
I will swim next weekend.	Dad will make a cake tonight.
I swam on Saturday.	We're going to watch TV this evening.
I will play football next year.	We watched television last night.
Dad made a brilliant cake.	I played football yesterday.
I have swum twenty lengths.	We watch television most days.
I am going to swim on my birthday.	He tidied his room last week.

Name:

Get it right

■ For each passage below insert the correct verbs. Remember you may have to change the spelling of the verb or add a modal verb.

Victorian children

Verbs: go, eat, live, catch, work, drink, learn

Conditions for many children were often harsh in Victorian times. They often

_____ in factories and _____ in squalid conditions. Poor children

_____ little and often _____ nasty diseases, often because they

_____ dirty water. Lucky children _____ to school where they

_____ to read and write.

Refugee children

Verbs: provide, live, have, sleep, catch, keep up, get

Many children around the world have to flee from war and famine. They

often _____ in camps and _____ in cramped rooms. Charities

_____ some food for them, but they can still _____ nasty diseases

because sometimes they cannot _____ clean water. In some refugee

camps children _____ lessons so that they can _____ with

their learning.

One day all children...

Verbs: drink, have, learn, go, eat, work, fight

Many people hope that one day all children _____ equal rights.

They _____ to school and they _____ enough to make them

independent. They _____ healthy food, and they _____ clean

water. They _____ never _____ in wars, and they _____

only _____ in jobs that they want to do, and that are safe.

Know your time

■ Look at the examples of time below and see how many different examples of time you can find in books and texts.

Time	Example
Past	I worked all day yesterday.
	I had worked all day and I was exhausted.
	I had been working all day when it happened.
	I was working all day and I didn't see anything.
Present	I walk to school each day.
	I have walked to school because the bus was late.
	I have been walking for over an hour now.
	I am walking to school tomorrow.
Future	I will write a letter to you.
	I will have written the letter by two o'clock.
	I will have been writing for over an hour.
	I will be writing a letter to you next month.

My examples	Time

What is a modal verb?

Objective

Identify modal verbs and understand their function in a sentence.

Background knowledge

Modal verbs can express such qualities as certainty, ability or obligation. The main modal verbs are 'will', 'would', 'can', 'could', 'may', 'might', 'shall', 'should', 'must' and 'ought'. They only have finite forms and never have suffixes. Note that 'ought' is usually followed by 'to', for example, *I ought to go now*.

Activities

● **Photocopiable page 67 'Uncertain Ernie – identifying modal verbs'**
This short letter contains fifteen examples of modal verbs, with all ten covered at least once. As well as asking children to identify them, discuss the meaning each one implies, from doubt to certainty, to prepare children for subsequent activities. Also covered are one or two modal verbs in question and negative form. Again, these can be drawn out for further exemplification and discussion.

● **Photocopiable page 68 'Modal nuances'**
Children are challenged to rewrite statements as sentences including modal verbs. It is possible for them to use all ten modal verbs presented but this may not happen. Use follow-up reviews to encourage children to compare and discuss answers.

● **Photocopiable page 69 'Using modal verbs'**
This exercise asks children to explore possible uses of these words. Children will have already used modal verbs extensively in their writing and conversation but this addresses them in isolation as a feature of language.

Further ideas

● **Listen for modals:** Children can listen to extracts of television and radio news and try to spot the use of modals. Items involving interviews with politicians can be a gem in this activity, particularly when the interviewer is trying to tie them down to a *Will you...?* and the politician will only offer a *We should...* or *We might...* in response.

● **The modal scale:** Draw a line on your whiteboard and write 'impossible' at one end and 'certain' at the other. In discussion, ask the class to agree on the positioning of each modal on this line, using examples to substantiate their views. Extend this to negative constructions too, noting good examples.

● **Q&A:** Challenge the class to think of a valid question for each modal verb, such as *Could you pass the salt please?*, and then craft an appropriate answer to each one. Some modals feel awkward as questions and some (such as 'could') are formed around politeness. It is also interesting to note where and why answers do not need modals.

Digital content

On the digital component you will find:
● Printable versions of all three photocopiable pages.
● Answers to 'Uncertain Ernie – identifying modal verbs'.
● Interactive version of 'Uncertain Ernie – identifying modal verbs'.

What is a modal verb?

Uncertain Ernie – identifying modal verbs

■ Poor Ernie has been invited on a camping holiday but can't make up his mind! Look at the passage of writing below and circle or shade every modal verb. (There are fifteen altogether, and all ten appear at least once.)

■ Look out for negatives and questions – the modals stay the same but other words change.

Modal verbs:

will would can could may

might shall should must ought

Dear Albert,

I would love to come camping with you but I'm afraid it might rain, and I can't get my new haircut wet – it might not look nice when it's wet. Perhaps we could stay in a hotel instead, although it may be rather expensive. I wouldn't mind paying, though I couldn't afford anything posh.

I suppose we ought to go. No, in fact we must go: I'm sure it will be fun. I just feel we should wait and see if the weather will be good. Can you give me a day or two to decide, and then I promise I shall give you my answer?

Yours worryingly,
Ernie

Name:

What is a modal verb?

Modal nuances

Modal verbs are used alongside other verbs to suggest things like probability, obligation or ability. When we talk we use them without thinking, but it is a bit harder to write effectively with them.

■ Look at each of the statements below and write a response to each one using a modal verb in your answer. It is possible to use a different modal verb each time, but you do not have to.

Modal verbs:

will	would	can	could	may
might	shall	should	must	ought

Example: Rain in the desert. _It can rain in the desert._

1. Snow at Christmas. _____

2. Go shopping. _____

3. Play tennis. _____

4. Learn your spellings. _____

5. Eat your greens. _____

6. Say thank you. _____

7. Be nice to teachers. _____

8. Go to school. _____

9. Be kind to others. _____

10. Win the lottery. _____

What is a modal verb?

Using modal verbs

Modal verbs change main verbs.

In front of a verb like: | I run. |

you can place a modal verb: | I **could** run. |

to show how likely or unlikely the verb is: | I **will** start running when I hear the bell. |

or how certain or uncertain it is: | I **might** run in the race tomorrow. |

■ Make a sentence for each of the modal verbs below. You can use each one with any other verb that you want to, such as *walk*, *eat*, *go*, and so on.

Modal verbs:

will	would	can	could	may
might	shall	should	must	ought

1. _____

2. _____

3. _____

4. _____

5. _____

6. _____

7. _____

8. _____

9. _____

Writing with modal verbs and adverbs

Objective

Use modal verbs and adverbs to express possibility in writing.

Background knowledge

The modal verbs can be roughly divided into three categories:

- **Sure:** must, shall, ought to.
- **50–50:** will, should, would, can.
- **Unsure:** may, might, could.

Of course this is not exact – for example, most people take 'might' to be less certain than 'may' – but it is useful for appreciating the range of meanings these verbs allow us.

As well as using modal verbs to add nuance to the meaning of verbs, we can also employ adverbs to enhance meaning. Adverbs can be used instead of modals, but also alongside them in many cases, such as *I could possibly come to your party*.

Activities

- **Photocopiable page 71 'In your dreams'**
This activity develops children's understanding of modals by matching situations to particular verbs to generate sentences about possible events. It is worth exploring the difference a change of modal can make. For example, *If I become a millionaire* may generate a different response for the modal 'I will' and 'I should'. The second might prompt feelings of obligation.
- **Photocopiable page 72 'Modal degrees'**
As a way of exploring the differences between modals, this activity leads children to use different modal verbs in different ways. In doing so, it explores how probable and certain the various modals are. Children may debate which statements they think they can make under each heading. They often end up philosophically asking whether anything is certain!

- **Photocopiable page 73 'Definitely maybe'**
This is a sorting exercise to develop children's awareness of adverbs that express degrees of certainty. Follow up this exercise by asking children to discuss their choices – the sorting isn't exact – as well as looking at constructing sentences using these adverbs, in particular focusing on sentence construction that uses a modal verb and an adverb. The normal construction is modal – adverb – verb (for example, *I will probably come*).

Further ideas

- **Predictions:** Using modal verbs, children can make predictions about future events in a story they are reading or a series they are following on the television. As on photocopiable page 72 'Modal degrees', they can try to rate the likelihood of events.
- **Hot seat:** Arrange the usual hot-seat-type activity where children have to answer questions from a group, but they can only answer using an adverb of possibility, perhaps referencing the bank of words on photocopiable page 73 'Definitely maybe'.
- **Be clear:** Work with children to create a bank of expressions that contain a modal verb and an adverb that provide clear statements (for example, *I shall definitely buy it; we could possibly afford it; they must never return*; and so on) and consider situations where these expressions might be used.

Digital content

On the digital component you will find:
- Printable versions of all three photocopiable pages.
- Answers to 'Definitely maybe'.
- Interactive version of 'Definitely maybe'.

Writing with modal verbs and adverbs

In your dreams

Modal verbs can be used to show things we will do, or could do.

■ Match the situations below with a modal verb. For example:

If I become prime minister	I will

■ Finish off the sentence. For example:

If I become prime minister	I will	extend the school holidays.

■ Write the full sentence down on another sheet of paper.

Situations	Modals
If I become a millionaire	I would
If I became prime minister	I could
If I get shipwrecked on a desert island	I might
When I am old enough to do a job	I should
If I became famous	I can
When I move into my own house	I will
When I can go on holiday by myself	I shall
When I can choose a pet of my own	I may

Name:

Modal degrees

Some modals say things are sure to happen.
The rain **will** stop at some time.

Some say they are likely.
It **should** brighten up later on.

Some just say they could happen.
It **might** stop before playtime.

■ In the table below, think of some things that definitely will or won't happen tomorrow:

It will… I shall… My teacher won't…

some things that are likely to happen tomorrow:

It should… I should…

and some things that might or might not happen tomorrow.

We might… I could…

Some things that definitely will or won't happen tomorrow	Some things that are likely to happen tomorrow	Some things that might or might not happen tomorrow

PHOTOCOPIABLE

Writing with modal verbs and adverbs

Definitely maybe

Just as modal verbs can express how sure or unsure we are, so can adverbs. There are many more adverbs than modals. There is a box with some of these adverbs at the bottom of the page.

■ Sort the adverbs into appropriate columns.

	Sure	50–50	Unsure
Modal verbs	shall, must, ought to	will, should, would, can	may, might, could
Adverbs			

undoubtedly	scarcely	usually	always
never definitely	occasionally	apparently	clearly
positively	perhaps obviously	often	certainly
uncertainly	surely	possibly	rarely
likely	unquestionably	probably	regularly
generally	frequently	impossibly maybe	unlikely

Verbs in writing

Use verb forms and verb tenses accurately in writing, and use verbs and adverbs to indicate degrees of possibility.

Writing focus

Building on previous activities, this section offers children the chance to use various tenses and forms of verbs and to explore the potential use of these in creative writing.

Skills to writing

● **Tense stories**

No, this isn't about writing cliff-hangers, but a way of encouraging children to use different tenses in their writing. Rather than trying to create whole stories, focus on very specific episodes that involve the use of particular tenses. For example, imagining that an attack on a castle has been repelled and an account of the preparations needs to be made will encourage use of the past-perfect tense, such as *we had raised the drawbridge and we had positioned our archers before the enemy arrived*. Through the story children will need to be aware of, and later check, that they are consistently using the appropriate tenses (and are ensuring subject–verb agreement at all times too).

● **Modal meaning**

Examine the varying ways in which modal verbs affect the action presented in a sentence. This is a feature of conversation – and one quite common in schools. When the children ask the head teacher *Will we all be going to the pantomime this year?* the answer *We will* is very different from *We could* or *We might*. It also avoids having to say *We won't*. Tune children in to 'spot the modal' – whether in conversation at school or examples shared from home (*Mum, can I go to town with my friends? You might be able to*). As they catch various examples, encourage them to look out for how certain

or vague the action is, when the modal is used. (I recall the time a girl said, in school council, responding to my *We may…* with the words, *Is that a 'yes' or a 'no'?*)

● **Persuasive modals**

Watch out for the use of the modal in persuasive writing. The firm declaration that something will lead to a result is different from the threat that it might. The notion that children watching soap operas might result in them becoming rude, or a leaflet suggesting that a new road could increase traffic through a village, are the sorts of modal usages that can raise spectres for persuasive purposes.

● **Verbs and adverbs for story planning**

It can be interesting to ask children to create a plan for (say) an adventure story that includes the modal verbs and adverbs that they will use in each section. Look at how uncertainty can create tension and how certainty creates direction, creating a plan or storymap that lists modals and adverbs that are relevant to each section.

Activities

● **Photocopiable page 76 'Intergalactic memoirs'**

This activity provides a simple prompt and structure for children to write short pieces set in the past, present and future. Differentiate this task by encouraging use of continuous tenses as well as simple and perfect forms. There is also an item in the 'Write on' section below as to how this might be developed into a piece of extended writing.

● **Photocopiable page 77 'I might…'**

This photocopiable sheet presents a range of options for the use of modal verbs in conversation. Children can use this to make notes as part of the process of narrative writing. To do this, they need to select a scenario, and then, in each of the speech bubbles, they need to write something a character could say at this point in the story. Can they use these lines in their story writing?

Write on

● Space story

Use children's work on photocopiable page 76 'Intergalactic memoirs' as a starting point for extended writing, choosing one or more of the sections for a more in-depth memoir or story set in the past, present or future. This might also be an opportunity for using more than one tense relating to the time in focus, such as past perfect as well as past, present perfect as well as present, present continuous, to add variety and to clarify meaning.

● Manifesto

As a way to revise their use of modal verbs, ask children to review the sorts of rule you have as a school. Then ask them to draw up a manifesto of the changes they would make if they were given control. There are various ways of doing this that will emerge – the crucial one being, are they allowed to alter national laws about the curriculum and so on? Keep them focused on the task of simply devising a system that provides the best education and see what must happen, what will be changed, what should be done and so on.

● Write a future

Ask the children to write their dream future. Tell them the four rules for this to work well are that they must dream big dreams, the best they can imagine; they must also write about more than just their job (so we don't just get 500 words on playing football); they must imagine a career change in there somewhere and they must try to include some features that no one else in the room has thought or dreamed of. As they write this, ask them to vary the level of certainty, moving between what they 'will', 'might' and 'could' do.

● Yours uncertainly

To encourage the use of adverbs of certainty, and using the bank of adverbs on photocopiable page 73 'Definitely maybe' for support, imagine that children are in the roles of officials and set a range of scenarios that children might have to write letters for, such as a planned new road, the removal of trees from a village square, the planned closure of a playground, a new supermarket, and so on. Explain to the children that they have to write a letter or an article for the local newspaper explaining the current state of plans, and they can be as clear or opaque as they wish. Reviewing work as a class should provide children with the opportunity to spot each others' adverbs and comment on how certain each person's written piece is.

Digital content

On the digital component you will find:
● Printable versions of both photocopiable pages.

Name:

Verbs in writing

Intergalactic memoirs

■ You are one of a select group of people who have been chosen to leave Earth and go to live on Mars. The journey there will take over a year, and you have time to write about how your **past on Earth** compares with your **present on the spaceship**, and your **future on Mars**. Write about these times in the sections below. Try to use at least six of the verbs shown in each section.

| live eat drink work play wear see talk sleep wash |

The past on Earth...

The present on the spaceship...

The future on Mars...

PHOTOCOPIABLE ■SCHOLASTIC
 www.scholastic.co.uk

Verbs in writing

I might...

■ Use these sentence starters to plan the things your characters might, could or should say.

I might...

I could...

I won't...

I will...

I should...

I mustn't...

Chapter 4
Clauses and sentences

Introduction

This chapter develops children's skills in crafting multi-clause sentences that include relative clauses (and hence relative pronouns). After revising clauses, it develops knowledge of how to identify and construct these, with activities to write extended sentences in isolation and in longer passages. For further practice, please see the 'Clauses and sentences' section of the Year 5 workbook.

Poster notes

Relative pronouns (page 79)
This poster explains the basic function of the five relative pronouns, with examples for each. Display it on the whiteboard and discuss the technical aspects with the class, using the examples to reinforce position and function. Use your own discretion about the use of 'whom', which has slipped out of common usage apart from in polite questions (*To whom am I speaking?*). It may be that using 'who', and even 'that', is sufficient at this stage.

Relative clauses (page 80)
This poster reviews the meaning of clauses, in particular focusing on relative clauses. Used in conjunction with the relative pronouns poster it can be a useful resource for reinforcing grammatical terms and structures. Note that the last example uses 'which' to refer to the whole clause (not just the noun), meaning that a comma has to be inserted before it.

Vocabulary

Children should already know:
pronoun, punctuation, sentence, clause, subordinate clause
In Year 5 children need to know:
relative pronoun, relative clause

Clauses and sentences

RELATIVE PRONOUNS

that
which
who
whom
whose

Take note: these days people usually use **who** instead of **whom**. **Whom** is formal.

Relative pronouns replace objects or things to join relative clauses on to main clauses.

The relative clauses modify a noun in the main clause.

There are lots of different pronouns that do all sorts of things.

The words **who**, **whom** and **whose** are used for people, and **that** and **which** for things.

She owns the dog **that** is always barking.

She lives in a big house **which** is red and green.

She's the lady **who** owns the dog.

She's the lady **whose** dog is always barking.

Eleanor visited the lady for **whom** she had been walking the dog.

Clauses and sentences

RELATIVE CLAUSES

Relative clauses always start with a relative pronoun.

I walked to school today.
I ate pizza for lunch.

A relative clause provides information about the subject or object of the first clause.

Remember, these are who, whom, whose, that and which.

He's the boy **who** broke the window.
It was the large window **that was broken.**

A clause is a set of words that make sense – a clause will always have a verb in it.

Extra clauses can be added to give us more information. If they don't make sense on their own they are subordinate clauses. They are joined to the main clause with words like **so, though, because, then,** and so on.

I walked to school today **because the bus was late.**
I ate pizza for lunch **though I don't really like it.**

PHOTOCOPIABLE

Revisiting clauses

Objective

Revisit clauses.

Background knowledge

The purpose of this section is to revise children's previous learning concerning clauses. If their existing knowledge is not substantial, you may wish to spend more time introducing and/or revising the main concepts. Note that although relative clauses are a type of subordinate clause, this term is not introduced until the next section.

Activities

● **Photocopiable page 82 'Clause or not?'**
As a way of looking at the definition and understanding of the term 'clause', this activity asks children to sort bits of sentences that are complete clauses from bits that are not. There are two guidelines to draw to their attention as children undertake this task. Firstly, a clause is very much like a little sentence, indeed single-clause sentences consist of one clause. Secondly, a clause contains a verb. By looking for a chunk that functions independently with a verb, children should be able to pick out the clauses.

● **Photocopiable page 83 'Constructing complex'**
Often grammar only makes real sense when applied to actual texts children will encounter around them. This extract from *The Iron Man* by Ted Hughes has been chosen because of the interesting clause structure children will encounter within the text. Use this activity to revise what makes a complete clause, different clause types, and the use of punctuation.

● **Photocopiable page 84 'Find the main clause'**
This activity revises the idea of main clauses as opposed to subordinate clauses. This is a difficult idea and there are some grammatical pointers to distinguish the two. However, this activity depends to a large extent on children figuring out what the main action of the sentence is. Point out that main clauses can appear at the beginning or end of a sentence. Once they have identified the clauses they might be able to discuss how the subordinate adds to the main clause. Ask: *Does it explain when the main clause was done, or why, or how?*

Further ideas

● **Do I use clauses?:** Ask children to review a piece of their own recent writing and identify any main or subordinate clauses in it. Ask if they are using them effectively, and whether they can see how they might improve specific sentences by adding subordinate clauses.

● **Joining clauses:** Review with children the use of adverbs, conjunctions and prepositions for joining clauses. Displaying the words in the classroom, provide a selection of main clauses and ask children to add a subordinate clause by using one of the 'connecting' words.

● **Dots and dashes:** Following on from photocopiable page 83 'Constructing complex', spend time considering the role of punctuation in linking clauses. Write clauses without punctuation on the whiteboard and have children read them aloud, considering whether punctuation is essential for meaning or just to ease the flow of the sentences.

Digital content

On the digital component you will find:
● Printable versions of all three photocopiable pages.
● Answers for all three photocopiable pages.
● Interactive versions of 'Clause or not?' and Find the main clause'.

Revisiting clauses

Clause or not?

Clauses are distinct parts of a sentence. They usually contain a verb. They can look like a sentence. For example, this sentence:

| I will *see* you when I *get* a chance after I *eat* my tea. |

contains three clauses:

| I will *see* you | when I *get* a chance | after I *eat* my tea. |

each of which has its own verb and makes sense.

| I **will see** you | | when I **get** a chance | | after I **eat** my tea. |

■ In the sentences below, some strings of words are in bold. Some of the bold bits are clauses. Some are not. Can you sort the clauses from the non-clauses?

	Clause	Not a clause
Jamie ran away and he hid in the tree house.		
The little, green house is very old.		
My friend made a cake but **it tasted horrible.**		
My **best friend in the whole** school is leaving!		
My gran says she was around before the dinosaurs.		
One of the children let off a stink bomb and it made the whole playground smell.		
Every Saturday my sister works on her motorbike then she goes out for a ride.		

Revisiting clauses

Constructing complex

- Look at this extract from Ted Hughes's *The Iron Man*.
- Using coloured pencils, underline the different clauses in different colours.
- Circle any words or punctuation marks used to separate or join the clauses.

At last he stopped, and looked at the sea. Was he thinking the sea had stolen his ear? Perhaps he was thinking the sea had come up, while he lay scattered, and had gone down again with his ear.

He walked towards the sea. He walked into the breakers, and there he stood for a while, the breakers bursting around his knees. Then he walked in deeper, deeper, deeper.

The gulls took off and glided down low over the great iron head that was now moving slowly out through the swell. The eyes blazed red, level with the wavetops, till a big wave covered them and foam spouted over the top of the head. The head still moved out under water. The eyes and the top of the head appeared for a moment in a hollow of the swell. Now the eyes were green, then the sea covered them and the head.

The gulls circled low over the line of bubbles that went on moving slowly out into the deep sea.

Ted Hughes: *The Iron Man*

Revisiting clauses

Find the main clause

In sentences like this:

> We played outside after we finished our tea.

there is a main clause:

> **We played outside** after we finished our tea.

This is the main thing stated in the sentence.

Other bits, like this, are called 'subordinate clauses'.

> We played outside **after we finished our tea.**

This bit tells you when we did the main bit.

They are linked to the main clause and tell us a bit more about it.
The main clause is the main thing the sentence has to say.
It makes sense on its own.

■ Look at these sentences and sort the main clauses from the subordinate clauses. Circle the main clauses in red and the subordinate clauses in blue.

We played outside when the rain stopped.

I made my tea because I was hungry.

Because we were good this morning we got five minutes extra play.

Mum bought a motorbike so she could visit Gran.

The aeroplane took off after everyone was on board.

We are careful when we cross the main road.

Our teacher went home because he was ill.

The caretaker took us outside to teach us some football skills.

Because it was raining we stayed indoors.

Since we started school in September we've been on three trips.

While we were waiting for the bus we played a game of catch.

The garden was ruined after the cows trampled through it.

84 Scholastic English Skills
Grammar and punctuation: Year 5 PHOTOCOPIABLE SCHOLASTIC
www.scholastic.co.uk

What are relative pronouns and relative clauses?

Objective

Identify relative pronouns and relative clauses.

Background knowledge

In modern English there are five relative pronouns: 'that', 'which', 'who', 'whom' and 'whose'. These are used in relative clauses to refer back to a noun. We use 'who' and 'whom' for people and 'which' for things. 'That' is used for both, so it is also sometimes omitted. Note that 'whom' is grammatically correct when replacing an object, but 'who' is becoming accepted modern usage – as such its use in this section is restricted to questions.

A relative clause is a type of subordinate clause that modifies a noun and uses a relative pronoun. For example: *She's the girl who won the race*. (The word 'who' refers to the girl.)
It's the ball that broke the window. (The word 'that' refers to the ball.)

Relative clauses provide additional information without starting a new sentence. Using relative clauses can make texts more fluent and helps to avoid repetition.

Activities

● **Photocopiable page 86 'Relative pronouns'**
Children are asked to look at a selection of sentences, all containing pronouns. Firstly, they need to circle all pronouns and then identify which are relative pronouns.
● **Photocopiable page 87 'Relative clauses'**
Children must identify the relative clauses in a passage of text, as well as noting the relative pronouns and any uses of punctuation that accompany them.
● **Photocopiable page 88 'Meet the relatives'**
This straightforward activity requires children to write examples containing each relative pronoun used in a suitable clause.

Further ideas

● **Pop pronouns:** Challenge the class to a tallying activity, reading texts and charting how often relative pronouns appear. Are there any instances where they have been omitted?
● **Pronoun of the day:** For the duration of the children's work with relative pronouns, at the start of each day have one of the pronouns displayed on your whiteboard (plus other stimulating prompts if necessary). For five minutes, ask the children to think of/write as many sentences as possible using the pronoun shown.
● **Clauses about my relatives:** Challenge the class to write down the names of some of their relatives, and ask them to write three sentences, using 'who', 'whose' and 'that', for each of them.
● **Forming questions:** Provide the class with a passage of text (photocopiable page 87 'Relative clauses' will work for this activity) and ask them to identify any relative clauses. Then, challenge them to write comprehension questions that relate specifically to the clauses. For example: *Whose hair is blonde? Which car did Jodie get into?*

Digital content

On the digital component you will find:
● Printable versions of all three photocopiable pages.
● Answers to 'Relative pronouns' and 'Relative clauses'.
● Interactive version of 'Relative clauses'.

What are relative pronouns and relative clauses?

Relative pronouns

■ For each sentence, circle the pronoun(s). If there is a relative pronoun in the sentence, underline the word and write 'relative' in the box opposite.

It is my right hand that is sore.	
What is your name?	
It was Tom's coat which was stolen.	
Bob burned his breakfast, which made the whole house smell.	
They are the cakes that Jan baked.	
Tina was the one who scored the winning goal.	
Share your ideas with one another.	
The boy hurt himself on the climbing frame.	
He is the one whose dog escaped.	
Sam is the boy whose mum flies aeroplanes.	
The children helped each other make dinner.	
There was a terrible mess that took hours to clear up.	
You can help yourself to sandwiches.	
Mavis is a goat who can sing.	

Name: _____

What are relative pronouns and relative clauses?

Relative clauses

■ Read this passage of text and underline all the relative clauses in it.
■ Circle the relative pronouns and any punctuation that is used with the clause.

Annie West loved books. She read at least one a week, usually two. Her favourite reading place was the living room sofa, which was very old and tattered. Her worst place for reading was anywhere near to her younger brother Milo, who was always crashing around making lots of noise. Annie's mum, whose favourite pastime was also reading, would take little Milo to the park to give Annie some peace. They had just gone to the park that was nearest to their house. Annie knew she had a whole, free hour to herself.

Annie's current reading book was a thriller that was full of action and excitement. The heroine was a girl called Xana who had superhuman powers and was fearless. Xana had to save a city which had been invaded by aliens, whose leader was named Aaraston. Xana had just rescued an elderly man whom she had found hiding in his house, and now she was heading for the spaceship for the final battle with Aaraston. The spaceship was covered in spikes and made a terrible screeching sound, which filled Xana with fear.

Suddenly the living room door burst open, which made Annie jump. Milo hurtled into the room and jumped straight onto the sofa. Annie's cat, which had been curled up beside her, leaped away in fright and ran out of the room. Annie sighed. She would have to wait to find out what would happen to Xana – the superhero whose mission seemed doomed.

Meet the relatives

■ Write two example sentences for each relative pronouns.

which

Example sentences:

that

Example sentences:

who

Example sentences:

whose

Example sentences:

whom

Example sentences:

Using relative clauses

Objective

Use relative clauses in writing.

Background knowledge

Relative clauses can either provide essential or additional information. Clauses that are providing additional information use commas. Firstly, take this sentence: *John Smith is the player who scored the goal.* Here the relative clause provides 'essential' information about John Smith to help the reader identify him.

Now examine this sentence: *John Smith, who grew up in Birmingham, is going to be the new head teacher.* Here the relative clause provides 'additional' information about John Smith, so commas are needed.

Furthermore, relative clauses can also be attached to a clause, and for this the pronoun refers back to the whole clause, not just the noun, with the clause typically separated by a comma. For example: *Ian broke his pencil, which distracted Anna.* Without the comma this would suggest that the pencil distracted Anna, not the breaking of it.

Activities

● **Photocopiable page 90 'Fancy that!'**
This activity focuses on relative clauses that use 'that'. Children have to rewrite sentences changing 'that' to 'who' or 'which'.

● **Photocopiable page 91 'Bare bones'**
Children are challenged to identify and remove non-essential information. In reviewing work, be sure to read the reduced text aloud to demonstrate how it still makes sense.

● **Photocopiable page 92 'Clauses with commas'**
This activity presents ten sentences all written without commas. Some require commas to separate the non-essential information. It may be useful to display these on a whiteboard and discuss them with the class,

initially identifying relative clauses and then considering which ones are providing essential information, and which are not.

Further ideas

● **Gossip:** Ask the class to write sentences about themselves or their peers that contain non-essential information. These can be as daft or as funny as desired, providing the information is not essential – in other words it is not essential to identifying the person about whom it is written.

● **Comma quest:** Using appropriate texts or children's current reading books, ask them to scan for commas. Whenever they find a comma they should read the sentence with and without the comma to help reinforce the effect on the flow of the text, and then decide if the comma is separating a clause in any way.

● **Descriptive synopses:** Ask the children to consider a book (or film) that they are familiar with, and ask them to write detailed sentences about it that provide clear information about the characters, objects and settings. For example: *Bilbo Baggins, who lived in a well-furnished hole in the ground, was a hobbit.*

Digital content

On the digital component you will find:
● Printable versions of all three photocopiable pages.
● Answers for all three photocopiable pages.
● Interactive version of 'Clauses with commas'.

Using relative clauses

Fancy that!

■ There are five relative pronouns that we use for starting relative clauses: 'who', 'whose', 'whom', 'which' and 'that'. The last one, 'that', is special because it can replace 'who' and 'which'.

Using 'that'	Using 'who' or 'which'
He had a laptop **that** kept breaking down.	He had a laptop **which** kept breaking down.
There once was a girl **that** never ate her greens.	There was a girl **who** never ate her greens.

■ Rewrite each of these sentences using 'who' or 'which'.

1. Snow White ate the apple that had been poisoned.

2. Cinderella fled from the prince that had fallen in love with her.

3. I think he is the man that stole your bicycle.

4. That's the dog that ate your dinner!

5. I only like books that have a happy ending.

6. Mr Jones is the only teacher that lets us play football in class.

Using relative clauses

Bare bones

■ Edit this text so it only includes the essential information in the main clauses.

The school's Christmas disco, which was on the last day of term, was a huge success. Mrs Adams, the head teacher, danced non-stop for two hours, which was longer than anyone had ever seen her move before! She even danced to the song that lasted for 20 minutes, and she kept dancing after it had finished, which was most embarrassing. Little Marty Peters, who lives over the road, tried to join in the dancing, but he was wearing flip-flops which made him fall over. Then the DJ, who could not stop laughing, fell off the stage.

Mr Williams, the caretaker, who has worked at the school for over 50 years, had to call an ambulance. When the ambulance arrived, with its light flashing and siren sounding, the DJ said he was okay and put another record on! Everybody joined in a giant conga around the school; even the ambulance driver and her assistant, whose name was Betty, joined in.

Name:

Using relative clauses

Clauses with commas

Relative clauses that provide essential information do not need a comma before them. Ones that provide additional, non-essential information do.

■ Decide whether each of the sentences below needs a comma or two, or not. Then insert the commas in the correct places.

1. We watched the entire match which made us late for the party.

2. We watched the football match which was on channel three.

3. I have one white cat whose name is Tinker.

4. It was the cat whose tail is short.

5. The man who stole the car was arrested.

6. That man who once stole a car is a famous politician.

7. The door which leads to the treasure is red.

8. We live in a large house which is nice.

9. Jim whom we met yesterday is very nice.

10. She wrote to the girl whom she had met on holiday.

Extending sentences using clauses

Objective

Consolidate and extend work on using clauses in writing.

Background knowledge

The transition to effective use of clauses is critical in children's linguistic development. Understanding clauses will assist them with their reading, helping them to use appropriate intonation and pace, and their writing will become more fluent and descriptive.

Understanding the grammar is a more complex affair, as there are many variations and types. For the moment, appreciating what clauses are and knowing that clauses can be inserted within the main clause, using parenthesis or following it is sufficient.

Activities

● **Photocopiable page 94 'Clauses in parenthesis'**
In this activity, children take a clause and locate the point at which they would insert parenthesis within a sentence. In reviewing work, ask children to identify relative clauses, as well as look at other possible constructions for each expanded sentence.

● **Photocopiable page 95 'Linking and inserting clauses'**
Children are provided with a range of sentences, and some additional information for each one. The challenge is for them to rework the sentences to include the additional information, with guidance showing them how this can be done in more than one way. This provides excellent practice for children in considering the different constructions and forms of clauses, and follow-up work should focus on different constructions, using this as an opportunity to explicitly review the grammar using the correct terminology.

● **Photocopiable page 96 'Police reports'**
This activity requires children to use their imaginations in constructing a detailed report full of information. They may require some examples/prompting to help them

see how to use the information to generate extended sentences that describe people, places and events, perhaps using all five relative pronouns once for each report.

Further ideas

● **Spot the parenthesis:** Provide a selection of sentences containing parenthesis, but with no commas to demarcate them. Working individually or with the whole class, children must consider where the commas are inserted. Reading the sentences aloud both without and then with correct commas can help children to understand their purpose.

● **Multi-clause practice:** Children can practise producing multi-clause sentences on a whiteboard or sheet of paper shared by a group. Challenge the children to look at the ways in which they can alter sentences and add extra information and clauses.

● **Shrink it:** Try providing children with a passage full of extended sentences, including their peers' work if appropriate, and ask them to create a bare-bones fact file about the subject, removing all additional information, starting by identifying all the subordinate clauses, whether in parenthesis, personal or otherwise.

Digital content

On the digital component you will find:
● Printable versions of all three photocopiable pages.
● Answers to 'Clauses in parenthesis' and 'Linking and inserting clauses'.

Name:

Extending sentences using clauses

Clauses in parenthesis

■ Look at these sentences. They each have a strip that can be put in parenthesis somewhere in the middle of the sentence.

| The dog, | who had caught a bad dose of fleas, | scratched and scratched. |

■ Cut out the strips and stick them on a sheet of paper. Correctly place the clauses in parenthesis, marking them with commas.

My great grandmother	rides a motorbike.	who comes from Cornwall
My house	needs lots of repairs.	which is very old
You are	a great class.	I can honestly say
My mum	is going to have a big party.	when she celebrates her birthday
Our football team	is the best in our area.	having won the cup
My dad	comes home at weekends.	who works in London
Astronauts	eat food from tubes.	while out in space
Our cat	needs a bath.	who happens to smell

Extending sentences using clauses

Linking and inserting clauses

Clauses can provide more information in a sentence.

Look at this sentence. | Mum likes a cup of tea.

Here is another piece of information that could go in the sentence.

| She likes one when she gets home from work. |

The sentence can be reworked to include that piece of information in several ways:

Mum likes a cup of tea when she gets home from work.
When she gets home from work, Mum likes a cup of tea.
Mum, when she gets home from work, likes a cup of tea.

■ Put the extra information below into each of the sentences.

Sentences	Extra information
Mum hires a car.	She hires it when we go on holidays.
Our teacher wore a suit today.	He is usually scruffy.
The children had to walk.	They had missed the bus.
Our car went to the mechanic.	It has stopped working.
Sam went to the hospital.	This was after he fell off the slide.
Grandad washed his hands.	This was before he made a cake.
Everyone cheered Sara.	She had scored a goal.

Reworked sentences

1. _____

2. _____

3. _____

4. _____

5. _____

6. _____

7. _____

Name:

Police reports

PC Dobbles has had a busy night! He has been out and about in Muddletown trying to catch criminals and investigate reports of crimes. Now he is back in the police station with a warm mug of cocoa, and has to write a report about each of the crimes. Can you complete them for him? Write them on a separate sheet.

Try to use as many extended sentences as possible by adding clauses. You can invent extra information if you need to. Remember that relative clauses start with: 'that', 'which', 'who', 'whose' and 'whom'.

Example: I chased Tricksy the cat because she was screeching loudly. She has sharp claws which she used to scratch me, and a bent ear that flapped in the wind.

Arch villain Tina Mimms, the one with a scar on her nose.
Stole a teddy bear from little Tommy Blimp, age five.
From his bedroom in Alby Avenue.

Tommy thinks it was just after the town clock struck midnight.
Muddletown goodie-goodie Jimbo Tosh, owner of 45 teddies.
Seen throwing stones at Mrs Plantem's greenhouse in Growit Street.
Nobody knows why he was out in the middle of the night in his pyjamas.

Bonzo the dog, with a very loud bark and a long tail.
Digging holes in Pretty-view Park.
May have been burying a bone.
(A bone was stolen from butcher Smith earlier this afternoon.)

Tricksy the cat.
Singing loudly and waking everyone.
Has sharp claws and one bent ear.
Might have been locked out.
Belongs to Tina Mimms.

PHOTOCOPIABLE

Clauses in writing

Objective

Use the concept of a clause as a tool for shaping sentences, including relative clauses.

Writing focus

Building on previous activities, this section encourages children to explore further work on clauses and the ways in which they are connected, including specific work on relative clauses.

Skills to writing

● Main clause

As you encounter sentences in shared reading or other texts in class, look out for examples of multi-clause sentences and, where possible, ask children to isolate the main clause. Remind them that this is the clause that the sentence needs – whereas subordinate clauses can be trimmed while the rest of the sentence retains its meaning. They might also identify relative clauses and point out whether subordinate clauses are in parenthesis.

● Gobbledegook prize

Encourage children to seek out the most complex printed sentence they can find. It can be one with loads of different clauses, variously connected, with commas and conjunctions everywhere. Set a challenge to find the most complex example.

● Less is more

Many authors have a range of techniques for developing stories and generating interest, and it is not always the case that providing detail helps. Using a shorter book such as *The Butterfly Lion* by Michael Morpurgo, look at extracts with the class and consider sections where less information is provided. What is the effect of shorter sentences, and what is the effect of having less information? This activity is important to help children remember that not every sentence needs to be extended and overly descriptive.

● Punctuation focus

Select an appropriate passage of text and highlight only the punctuation, discussing the function of each item, and in particular noting which elements of punctuation are there because of clauses. Next, consider the possibility of adding or removing clauses and how this might affect the punctuation.

● Helpful instructions

Find a suitable set of instructions, perhaps for constructing flat-pack furniture, or a recipe (recipe books are often great for extended sentences as they say why you must do something, and what happens if you do). Examine the instructions and identify any extended sentences. In the case that there are no subordinate clauses providing more detail, can you add them? To extend this, ask the children to write instructions for an everyday activity, such as boiling an egg, adding a clause to expand the level of detail at each stage.

Activities

● Photocopiable page 99 'Santa's clause'

This activity provides a range of information about Santa, with children challenged to construct a paragraph about him containing extended sentences. Make this more challenging by insisting that it must contain all five relative pronouns as well as other clauses, including the use of parenthesis.

● Photocopiable page 100 'Sentence crafting'

This photocopiable sheet is a tool for the revision process. Children select four sentences, either from texts they have written or read, that might be improved with relative pronouns. Then they can revise the sentences in the box on the right.

Write on

● Connection chatting

As part of their preparation for narrative writing, ask children to plan ahead and think of a conversation that will take place between two characters in their narrative. Ask the children to revisit the end of each line of dialogue and see whether a comma and a conjunction could both extend and enrich the dialogue. Two examples worth promoting are the use of 'although', where a character has said something clearly and can think of an exception, and 'but bear in mind', where the character wants something to be taken into account. Explain to the children that this treatment isn't for every line – but could be used for a few.

● One-sentence stories

Challenge the children to come up with a whole story in one sentence. This is different from the days when they didn't use full stops because they didn't know how to use them. Now, using a skilled combination of commas and joining words, children need to produce a story that extends a sentence into a convoluted set of events. For example: *The Princess married the Prince* becomes *Even though he was a frog, the Princess married the Prince.* Then: *Even though he was a frog, and despite the efforts of the bad fairy who tried to stop the wedding, the Princess married the Prince.* (Try adding an 'although' at the end and the story will be extended even more.)

● Comma and

Devise sentences with certain patterns to them. One example is the 'comma and', with two clauses separated by a comma then a third following 'and'. (*I put on my shoes, I grabbed my coat and I ran out the door.*) At first the model will lead to forced examples, but children start to both take on the rhythm of sentences and take structures from other multi-clause sentences to adapt for their own content.

● All about me

Ask the class to write the phrase *I'm the girl/boy/one…* on a piece of paper, choosing the final word as preferred, then create as many relative clauses as possible that can be added to the end. As these relate to a person, these clauses will require 'who' or 'whose' at the start, providing good reinforcement in distinguishing between subject/object and possession. Other relative pronouns can be brought into use with the phrase *I go to the school…* or something similar.

● On and on and on (and on)

Reminding children of the five relative pronouns and their use in relative clauses, challenge them to write as long a sentence as possible using each relative pronoun once (you may wish to be flexible about the use of 'whom'). For example: *He's the teacher who owns the dog that bit my leg which swelled up so much I had to see the doctor whose dog is nice and to whom I am most grateful!*

Digital content

On the digital component you will find:
● Printable versions of both photocopiable pages.

Clauses in writing

Santa's clause

■ Look at these facts about Santa and then write a descriptive passage about him, using extended sentences with clauses to provide as much information as possible.

Example: *Santa, who has a large white beard, lives at the North Pole. He has hundreds of elf assistants who help him to make the toys. He is always exhausted on Christmas Day because…*

Santa	Extra info
Lives at the North Pole.	The North Pole is very cold.
Makes toys for children.	Has hundreds of elf assistants.
Busy on Christmas Eve.	Santa's sleigh has an engine.
Exhausted on Christmas Day.	Some houses have no chimneys.
Goes on holiday to Hawaii.	There is a posh hotel in Hawaii.
Best friends with Rudolph the red-nosed reindeer.	Rudolph has a very red nose.
Loves mince pies.	Mince pies are fattening.
Has a big white beard.	It is hard to shave without a mirror.
Wears a bright red tunic with a furry hood.	Fur keeps you warm.
Favourite pastime is doing jigsaws.	Some jigsaws have 10,000 pieces.
Often says "Ho ho ho".	Lots of people like to impersonate him.

Name:

Clauses in writing

Sentence crafting

■ Write your original sentence in the left-hand column. Then use the relative pronouns shown to improve it, writing your new sentence in the right-hand column.

| that | which | who | whose | whom |

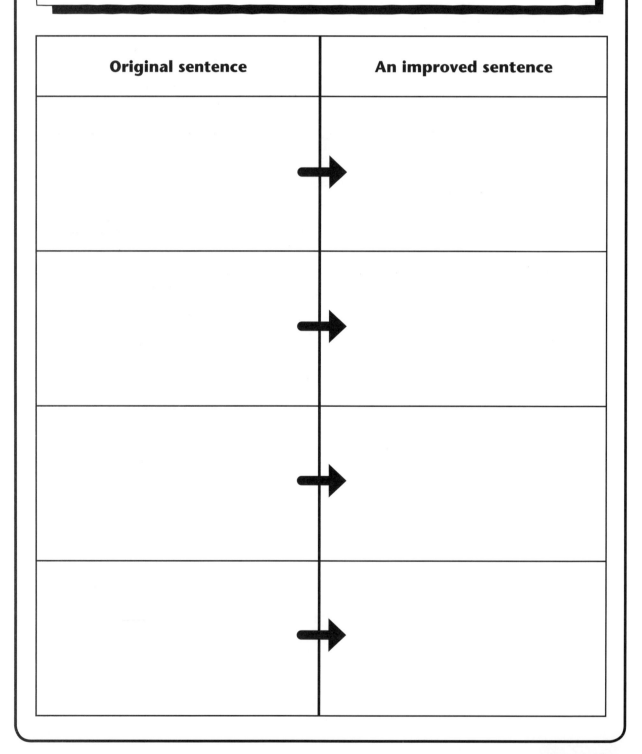

Original sentence	An improved sentence

Chapter 5

Cohesion

Introduction

Texts are cohesive, or have cohesion, when it is clear how the meanings and parts fit together. For example, look at these sentences: *The football team lost their match. All of the players were upset.* The underlined words refer to the same group of people, aiding cohesion while avoiding repetition.

Cohesive devices are words or phrases which help to achieve this, such as:

- Determiners and pronouns, which can refer back to earlier words.
- Conjunctions and adverbs, which can make relations between words clear.
- Ellipsis of expected words – in other words, text being omitted where the meaning is already clear. Note that, according to the National Curriculum, 'ellipsis' is a Year 6 term, and as such it is introduced here at a basic level.

For further practice, please see the 'Cohesion' section of the Year 5 workbook.

In this chapter

Building cohesion into writing page 104	Develop understanding of cohesion and begin to build cohesion within paragraphs.
Adverbials page 108	Revisit adverbials.
Linking ideas across paragraphs page 112	Link ideas across paragraphs.
Text structure page 116	Use organisational and presentational devices to structure text.
Helping the reader page 120	Consider how to build cohesion within and across paragraphs.

Poster notes

Cohesive devices (page 102)

This poster provides a simple overview of the key ways that children can identify and use cohesive devices. Display it for the duration of the children's work on cohesion. Please note that 'ellipsis' and 'synonym' are both Year 6 terms in the curriculum, but simple examples are included here for completeness.

Structuring texts (page 103)

This poster provides an example of how paragraphs and other organisational devices can be used to effectively structure texts.

Vocabulary

Children should already know:
adverbial, paragraph
In Year 5 children need to know:
cohesion, ambiguity

Cohesion
Cohesive devices

When we make texts easy to read and make sense, we say we are using 'cohesion'. To do this we must choose words carefully. Look at the example below. The cohesive devices are in italics.

Individual sentences

Rashid was bored.

Rashid walked to the park.

Rashid went on the slide.

Rashid went on the swings.

Sam came to the park.

Sam asked Rashid to play football with Sam.

Sam and Rashid went to the grassy area.

Sam and Rashid played football.

Using cohesive devices for flowing text

Rashid was bored *so* *he* walked to the

 conjunction pronoun

park. *(He)* went on the slide *(then)* played on

 pronoun adverb

the swings. *After a while* his friend Sam

 adverbial

arrived and asked Rashid to play football

 conjunction

ellipsis – ('in the park' is omitted)

with *(him)*. *The boys* went to the grassy area

 pronoun for Sam synonym for Rashid and Sam

and began to play. *ellipsis: we don't repeat the*

 conjunction *word 'football' because we*

 know what they are doing

Definitions

Pronouns: words that take the place of nouns, such as **you, she, it, they.**

Conjunctions: words used to connect clauses and ideas, such as **because, so, and.**

Adverbs: words that modify verbs, such as **next, finally, then.**

Adverbials: words or phrases that do the same job as adverbs.

Ellipsis: deliberately leaving out words that are not necessary.

Synonym: words or phrases that mean the same thing as another word or phrase.

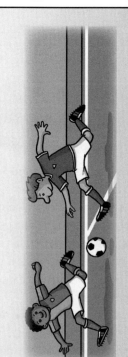

PHOTOCOPIABLE

Cohesion

Structuring texts

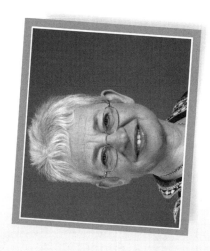

- Born in Bath in 1945
- Written nearly 100 books
- Sold over 30 million copies!
- Awarded the OBE in 2002
- Children's laureate, 2005–2007
- Became a dame in 2008
- Lives near London
- Has 15,000 books in her house
- Has one daughter
- Likes wearing big rings

Jacqueline Wilson

Jacqueline Wilson says that as a young child she was 'an earnest, shy, literary girl'. She wrote her first 'novel' at the age of nine.

A born writer

By the time she was 17 she was writing for a girl's magazine in Scotland – beginning her career as a writer for young people.

Success and fame

Although she had written over 40 books, it wasn't until *Tracy Beaker* was published that her work became very popular, and made her a household name.

These days she is always in demand. She has met lots of famous people, teaches at a university, and still writes lots of books.

Stories that matter

Her stories are about young people and their problems, which is probably why they are so popular. After all, we all have problems at one time or another.

SCHOLASTIC
www.scholastic.co.uk

PHOTOCOPIABLE

Scholastic English Skills
Grammar and punctuation: Year 5

103

Building cohesion into writing

Objectives

Develop understanding of cohesion and begin to build cohesion within paragraphs.

Background knowledge

Page 101 details some of the devices used for cohesion. While we take such devices in our stride when reading texts (the better the flow, the less we notice them), identifying them and indeed incorporating them into our own work is more difficult.

Look at the cohesive devices in these examples:

- *The cat meowed. <u>It</u> was hungry.* (The pronoun 'it' refers to the cat.)
- *We bought some flowers and chocolate. <u>The</u> flowers were beautiful.* (The determiner 'the' refers to the particular flowers.)
- *I'll put you to bed <u>after</u> supper.* (The conjunction 'after' makes the relationship of time clear.)

As an introduction to this area of grammar, the focus here is on conjunctions, adverbs and pronouns, with children asked to identify and consider the function of various examples of these words, though not having to name them.

Activities

● **Photocopiable page 105 'Cohesive words**
This is a straightforward activity in which children need to identify conjunctions and adverbs that improve the cohesion of a short passage of text. In discussing and reviewing children's work, focus on the conjunctions used and consider why they improve the cohesion and flow of the passage.

● **Photocopiable page 106 'Dear Diary'**
Challenge the children to look for and consider the roles of adverbs, conjunctions and pronouns in creating cohesion. When reviewing work you may wish to distinguish between each of these three word classes.

(There are also some examples of ellipsis in the text, where words have been omitted as the meaning is clear – these can also be drawn out in the class review if desired.)

● **Photocopiable page 107 'Rewrite'**
This activity presents a piece of text with no flow and asks children to rewrite it to improve its cohesion and ease of reading, then to try to continue it by writing a concluding paragraph. (Note that this activity deliberately uses the text from Poster page 102 'Cohesive devices'.)

Further ideas

● **Cohesion spotting:** Over the course of studying this aspect of grammar, use a selected piece of fiction or children's own reading books and review the text for specific elements of cohesion, such as pronouns and conjunctions, considering how their use contributes to writing style.

● **Diary extract:** Children can try using a range of cohesive devices in their own diary extract, modelled upon the example on photocopiable page 106 'Dear diary'. As they look at the various words they could use to connect clause to clause, they should examine the different functions the words are performing in building the cohesion of the paragraph.

Digital content

On the digital component you will find:
- Printable versions of all three photocopiable pages.
- Answers to 'Dear Diary'.
- Interactive version of 'Dear Diary'.

Building cohesion into writing

Cohesive words

Conjunctions and adverbs make links within sentences to help with the cohesion of the text.

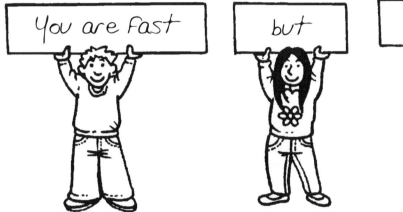

They can also make links across sentences, linking one sentence

> We had our tea.

with another

| We had our tea. | After that | we played outside. |

■ Look for the cohesive words in this piece of text. Think about what effect each of them has. Would the text make sense without them? Would it be as easy to read?

Marty was a popular boy, but Ross was more popular. This made Marty jealous, so he made a plan. Firstly, he saved his pocket money for a month and bought the largest bag of sweets he could find. Next, he used his computer to create a snazzy party invitation, inviting people to come and have tea at his house. Finally, he printed 45 copies of the invitation and put each one in an envelope along with a few sweets.

　　The next day, before school started, Marty walked proudly around the playground giving out invitations until he had none left. Now he was feeling very, very popular. However, he had decided not to invite Ross, and this made him cry, so Marty said that Ross could come too.

　　But there were two other people Marty had not told about the party – his parents – and he was just beginning to wonder about how they might feel when 46 noisy children arrived on their doorstep…

Name:

Building cohesion into writing

Dear Diary

■ Look at this diary entry and highlight any words or phrases that help with cohesion. What sort of job are they doing?

Monday 16 **June**

Creating cohesion

Some words help a text to be easier to read and understand, they make it flow better. We say they improve its cohesion.

Some words used for cohesion are:

Adverbs: firstly, then, meanwhile.

Conjunctions: after, but, next.

Pronouns: I, she, it.

Dear Diary, I am down in the dumps. First, Mum tells me we are moving house because she is sick of living so close to a main road. Then she announces we are moving closer to my Gran. Last week there was all that fuss about her and Gran falling out and then I find we're moving next door! I pointed out Gran lives next to a motorway but Mum has stopped listening. To cap it all, after all this Mum goes and loses the front door key so I was stuck outside for half an hour while she went round to Gran. After waiting for half an hour, I was bored so I went round to Saima's house but I didn't leave a note. When Mum got back she thought I had run away or I had been kidnapped, so firstly she gets all the neighbours looking for me. However, this is not enough. So she actually called the police! I was so embarrassed. Therefore I have decided not to speak to anyone for a week.

SCHOLASTIC
www.scholastic.co.uk

Building cohesion into writing

Rewrite

■ Take the sentences below and rewrite them to create a piece of flowing text using cohesive devices to help you, and then complete the story. Your story must have three paragraphs. Paragraph one has been done for you. You must create paragraph two using the sentences given, then create your own concluding paragraph.

Individual sentences	Using cohesive devices for flowing text
Rashid was bored. Rashid walked to the park. Rashid went on the slide. Rashid went on the swings. Sam came to the park. Sam asked Rashid to play football with Sam. Sam and Rashid went to the grassy area. Sam and Rashid played football.	Rashid was bored **so he** walked to the park. **He** went on the slide **then played** on the swings. **After a while** his friend Sam **arrived and** asked Rashid to play football with **him**. The boys went to the grassy area **and began to play**.
Rashid and Sam were thirsty. Rashid and Sam left the park. Rashid and Sam went to Rashid's house. Rashid and Sam had a drink. Rashid and Sam went to Rashid's room to play. Rashid had a car racing game. Rashid and Sam played the game until it was dark. Sam's Mum telephoned and asked where he was. Sam's Mum came in the car and collected Sam.	
■ Create your own final paragraph in the space provided opposite.	

Adverbials

Objective

Revisit adverbials.

Background knowledge

Adverbials are words or phrases that are used like adverbs (and including adverbs). Children may be familiar with the concept, including fronted adverbials (where the adverbial starts the sentence, such as *Later that evening, we heard noises outside.*). The purpose of this section is to revise and extend children's understanding of three different types of adverbials, those of time, place and number. These are covered in similar formats on each of the three photocopiable sheets:

● **Adverbials of time, including timing:** 'yesterday'; duration: 'since 2013'; and frequency: 'once a week'.

● **Adverbials of place:** including location: 'next to the cinema'; direction: 'past the tree'; and distance: 'from'.

● **Adverbials of number:** 'secondly'.

In considering words and phrases, it is helpful to show children how these improve the flow and cohesion of texts.

Activities

● **Photocopiable page 109 'Sort it out'**
This is a reinforcement activity that challenges children to categorise adverbials according to their function – are they focused on frequency and time, or place?

● **Photocopiable page 110 'Using adverbials of frequency and time'**
This photocopiable activity provides a selection of adverbial words and phrases that can be used to indicate frequency and time. Children are challenged to create their own sentences using them, with an extension to create three sentences that begin with adverbials.

● **Photocopiable page 111 'Using adverbials of place'**
This activity follows the same format as the previous activity, but focuses on adverbials to indicate direction, location and distance. As with the previous activity, children are challenged to create their own sentences using them, with an extension to create three sentences that begin with adverbials.

Further ideas

● **Name the adverbial:** Using a shared text, identify all the adverbials in it (ideally some will be phrases or clauses), then work through the adverbials considering their role in modifying the verb(s). If appropriate, extend this to consider how they affect the flow of the piece, perhaps rewriting sections without adverbials to show how the text can become dull and clumsy.

● **Number adverbials:** This area has a more limited set of words and phrases, such as 'firstly' and 'the second one'. Provide some simple activity-writing instructions, such as how to make toast, ensuring that every instruction has an underlined adverbial in it.

● **Front up:** Recap how adverbs and adverbials can be moved from after the verb to before it, and that adverbials at the beginning of sentences are usually followed by a comma. Challenge children to rewrite their sentences from the two 'adverbial' activities (pages 110 and 111) so that they begin with adverbials.

Digital content

On the digital component you will find:
● Printable versions of all three photocopiable pages.
● Answers to 'Sort it out'.
● Interactive version of 'Sort it out'.

Adverbials

Sort it out

■ Adverbials are words and phrases that give us more information about verbs. They often refer to frequency and time, or place. Can you sort all the words and phrases below in to the appropriate oval? Tick each word or phrase when you have decided where it belongs and then write it in the correct oval. Can you think of any others to add?

Adverbial words	Adverbial phrases
into	past the lamp post
yesterday	by the window
under	in the box
usually	since 2012
later	at the bottom of the ocean
sometimes	last week
across	all night
near	the day after tomorrow
tonight	from next Tuesday
	to the end of the lane

Adverbials of frequency and time **Adverbials of place**

Name:

Adverbials

Using adverbials of frequency and time

■ Look at these adverbial words and phrases for frequency and time. Write six sentences with them, or create your own adverbials.

Example: They **usually** watch television **in the evening**. (This sentence has two adverbials that describe the verb 'watch'.)

Adverbials of frequency and time			
yesterday	later		usually
sometimes	tonight	all night	since 2012
from next Tuesday	the day after tomorrow		last week

1. _____

2. _____

3. _____

4. _____

5. _____

6. _____

■ Make three sentences that begin with adverbials.

1. _____

2. _____

3. _____

Adverbials

Using adverbials of place

■ Look at these adverbial words and phrases for place. Write six sentences with them, or create your own adverbials.

Example: Go **into** the park and keep going **to the end of the path**. (This sentence has two adverbials.)

Adverbials of place			
into	under	cross	near
by the window	in the box		at the bottom of the ocean
past the lamp post			to the end of the lane

1. _____

2. _____

3. _____

4. _____

5. _____

6. _____

■ Make three sentences that begin with adverbials.

1. _____

2. _____

3. _____

SCHOLASTIC
www.scholastic.co.uk **PHOTOCOPIABLE** **Scholastic English Skills**
Grammar and punctuation: Year 5 **111**

Linking ideas across paragraphs

Objective

Link ideas across paragraphs.

Background knowledge

Children should be explicitly introduced to the idea of linking paragraphs using adverbials of time (such as 'next', 'in the evening'), place (such as 'in front of', 'nearby'), and number (such as 'twice', 'not for the first time'), as well as appropriate tense choices (such as 'he was safe', 'they had never been there before'). While many of these devices will be implicitly familiar, it is tricky to try and deconstruct or explicitly teach them. You will need to decide what depth to go to, and whether it is enough for their class to have your awareness raised via the suggested activities and ideas.

Activities

● **Photocopiable page 113 'Linking paragraphs using tenses'**
This activity focuses attention on how careful choice of verb tense, possibly along with pronouns and adverbials, can aid the flow and cohesion of texts. It focuses on fiction texts so that children undertaking fiction-based writing activities might apply their knowledge and understanding to new texts.

● **Photocopiable page 114 'Linking paragraphs in non-fiction'**
This activity provides a challenging writing task, to produce a letter arguing the points for and against a proposed expansion to the local school. It may be useful to model such a text in advance of the task, discussing the use of adverbials to aid cohesion between paragraphs.

● **Photocopiable page 115 'Experts in action'**
Children are reminded of Michael Morpurgo and Jacqueline Wilson, and presented with two brief snippets of texts from their books. The challenge is to identify the cohesive devices they have used across

paragraphs to aid cohesion. Children may benefit from reviewing poster page 102 'Cohesive devices' before attempting this task, then progress to studying other texts as in the 'Further ideas' section below.

Further ideas

● **Link spotting:** Ask the class to spend ten minutes every morning scanning parts of a book they have already read and to find paragraphs that link together, stating how the author has achieved this.

● **Help me out:** Ask the children to review each others' written work, say a story or report, focusing specifically on cohesion between paragraphs. Can they insert adverbials (at the front or otherwise) to aid flow and cohesion? (This task might be done as a follow up to the activities on pages 113 to 115.)

● **Feeling tense:** Work with the class to look at how established authors use verb tense to aid cohesion. Use this as an opportunity to revise verb tenses and consider how they help with the flow of ideas and structure between paragraphs.

● **Vocab bank:** Throughout this chapter, build up a bank of effective paragraph links, particularly adverbials, and display them clearly for children to access while writing.

Digital content

On the digital component you will find:
● Printable versions of all three photocopiable pages.
● Answers to 'Experts in action'.

Linking ideas across paragraphs

Linking paragraphs using tenses

■ When we write stories we can create cohesion by linking events – things that happen – between paragraphs. Look at this example:

…Tina picked up her suitcase, looked first at Tom, then Jenny, and walked slowly out of the living room and up the hall, slamming the front door behind her.

After she had gone her friends sat staring gloomily at the floor. Eventually Jenny stood up and looked out of the window at the empty street.

The start of the second paragraph has three different links:

After: adverbial

she: pronoun (for Tina)

had gone: this is called the past-perfect tense – it refers to an event in the past, which is Tina leaving.

(Try reading the second paragraph without this phrase – it still makes sense, but it isn't as clear.)

■ Look at these five endings of paragraphs, all from different stories. Copy them out on paper and write the start of a new paragraph that might follow each one, remembering to try to keep some cohesion.

1. …Zara saw the bird swooping towards them. She ducked for cover.
2. …I handed over the money and closed my eyes.
3. …Whatever anyone said about Trevor, he was not a coward.
4. …As the ship sank, we all clutched onto a life buoy, our teeth chattering and our minds praying.
5. …Mr Evans was entering the classroom, and that meant one thing.

■ Now use one of these as the basis for a complete short story.

Name:

Linking paragraphs in non-fiction

In letters, arguments, persuasive writing and recounts, new paragraphs are used to introduce a new point of view or the next in a sequence of events. In these types of text, new paragraphs don't usually have a subheading, and use adverbials at the beginning of the first sentence for cohesion. Common adverbials for such texts are shown in the box below.

firstly	secondly	finally	after that
alternatively	despite this	on the other hand	
as a result	nevertheless	however	even so

■ Read the task below and then use the adverbials to structure your letter into paragraphs.

Proposed school expansion

The local school wishes to build a new set of classrooms so that it can have better facilities and more children. The school is next to some houses and a large grassy park that is very popular with children and dog walkers. The plans include a two-storey block of classrooms, a new canteen, and some of the park being used to give the school a bigger car park. There is to be a meeting to consider different views about the new building work. Choose one of the people below and write a letter on their behalf:

- A parent of a child at the school
- The head teacher
- The owner of a nearby house
- A child at the school
- A local dog-walker
- The boss of the local building company
- The Mayor of the town.

PHOTOCOPIABLE ■SCHOLASTIC
www.scholastic.co.uk

Linking ideas across paragraphs

Experts in action

Most people love reading stories that they cannot put down. Sometimes these are called 'page-turners'. Writers like Michael Morpurgo and Jacqueline Wilson are experts at writing texts that people just don't want to put down. Of course they are great at imagining and telling interesting stories, but they also know how to keep the story moving along as well as making it easy to read. They are experts at cohesion.

■ Identify the different devices the writers have used in these two extracts.

adverbials

Suddenly, without a word, Matt got up from the sofa and stormed out, banging the door.

"What's the matter with him?" Olly asked. But she could see her mother was as mystified and as surprised as she was.

For some days now, she had known something was wrong with Matt…

From *Dear Olly* by Michael Morpurgo

…and then Jenny came in with coffee for Cam and coke for us and it was like some big party. Only I didn't feel like a birthday girl. I felt squeezed out to the edge again.

After a bit I stomped off. I kept looking back over my shoulder and thought she didn't even notice. But then she sidled up.

From *The Story of Tracy Beaker* by Jacqueline Wilson

SCHOLASTIC
www.scholastic.co.uk **PHOTOCOPIABLE** Scholastic English Skills
Grammar and punctuation: Year 5 **115**

Text structure

Use organisational and presentational devices to structure text.

Background knowledge

By this stage children should know the basics of paragraphs and other devices for organising texts. Poster page 103 'Structuring texts' provides a sample text containing a range of relevant presentational features, such as headings and subheadings. Following on from the activities in this chapter, children should be ready to consider the overall cohesion of their texts, allowing them to craft better, more rounded written pieces that flow smoothly from line to line, but that also have an overall shape and logic to them.

Activities

● **Photocopiable page 117 'Jumbled report'**
This activity presents children with an article about the considerations of owning a dog. However, all of its sections and headings have been jumbled up. By cutting out and rearranging these the children can develop their understanding of the importance of effective headings, subheadings and lists.

● **Photocopiable page 118 'Copy, please!'**
This activity presents the bare bones of a newspaper report, providing only the heading and subheadings. Note that it has two columns and space for an image. Children must decide on a theme and then write a report that fits in with the headings. (Stress to children that for texts printed on paper it is particularly important that they do not exceed the limits of space available – as they will be writing by hand they should think carefully about their words before they start working.)

● **Photocopiable page 119 'Not a dot in sight'**
This is a challenging activity. The photocopiable sheet contains a recipe for cupcakes written with no punctuation at all. Children must not only add punctuation, they must add subheadings, paragraphs and bullet points as they see fit.

Further ideas

● **Focus on the news:** Ideally bring a child-focused newspaper in to school, or an adult paper that has been carefully checked. Look at the headings, subheadings and style of writing, in particular the amount of text per paragraph. Next, following any event at school, from break time to sports day, ask the children to write a news report about it – either encouraging them to be very factual or to embellish it for more enjoyable and good-humoured reading.

● **Subheadings galore:** Using children's current reading books or any appropriate text that can be accessed individually or by the whole class, consider a paragraph (this usually works better without speech in it) and ask the class to create an appropriate 'title' or subheading for it. Comparing and discussing ideas and responses can help children to see that the appropriate choice of words is important for giving a clear indication of content and flow. To make it harder, set a limit of three words, two words, or even just one word.

● **Lists for everything:** Start each day with children making a list, whether a set of instructions or an inventory, such as the best procedure for washing hands or an alphabetical listing of school staff. Encourage them to think about numbering or bulleting their lists, and the implications of each format.

Digital content

On the digital component you will find:
● Printable versions of all three photocopiable pages.
● Answers to 'Jumbled report'.
● Interactive version of 'Jumbled report'.

Text structure

Jumbled report

■ Cut out and organise these headings, subheadings and paragraphs to make a report that is easy to read.

✂

So you're going to make a great dog owner. Remember that different dogs have different needs, but to be healthy and happy they all need certain things:
- Regular exercise
- Healthy meals
- Fresh water to drink
- A comfortable place to sleep
- Annual checkups at the vets (beware, this can cost money)
- Lots of attention
- Safe places to go if you have to leave them alone for a night or more.

Think about it

So far so good. You still want a dog despite all the work they need, but that may not be enough:
- Is your house suitable?
- Do you have a garden?
- Will your neighbours mind?
- Do you have other pets that might be afraid?

If you are still sure you can manage, you need to think about what to do!

A dog is for life, not just for Christmas!

Caring for your dog

If you can answer yes to all these questions you are probably going to make a great dog owner:

1. Can you afford it? You may have to buy the dog, and it will need feeding every day.

2. Are you a good teacher? Dogs need to be trained to behave themselves in the house and outside.

3. Can you be bothered? Dogs need walking (and to poo) once or twice a day.

4. Do you mind different smells? Dogs are animals, and although they like a bath they do smell differently to us. Most people don't mind this, but some do. Some people are even allergic to dogs.

So you're thinking about getting a dog, and who can blame you. There are millions of dogs in the UK that live with families and have very happy lives with them. However, they also come with needs that are important for us to understand, because they need lots of care and attention.

Check your home

SCHOLASTIC
www.scholastic.co.uk **PHOTOCOPIABLE** Scholastic English Skills
Grammar and punctuation: Year 5 117

Name:

Text structure

Copy, please!

■ The journalist writing this story for the front page of the newspaper has gone home for the night, and has accidentally deleted everything except the heading and subheadings of the article. You have to get it written again quickly! There isn't a moment to lose, and it is up to you to choose what it is about.

Trouble in Tumbletown!

1. Intro here

image here

Dangerous creatures

2.

Unhappy customers

3.

Little heroes

4.

Scholastic English Skills
Grammar and punctuation: Year 5
118

PHOTOCOPIABLE

SCHOLASTIC
www.scholastic.co.uk

Not a dot in sight

■ The recipe below has no punctuation or organisation. Rewrite the instructions using punctuation, subheadings, lists, bullet points and paragraphs to make a clear, easy-to-read recipe. You may use your own words if you prefer, and add instructions and ingredients if you wish.

How to make cupcakes

firstly check that you have all your equipment ready you will need scales mixing bowl whisk spoon cupcake tins then get all the ingredients ready butter sugar eggs flour milk to begin add all the ingredients and stir them until you have a good mixture next pour the mixture into the cupcake tins then put them in the oven bake for 20 minutes at gas mark four remove them from the oven and let them cool finally ice them and add your favourite sprinkles

How to make cupcakes

Helping the reader

Consider how to build cohesion within and across paragraphs.

Writing focus

Building on previous activities, this section provides opportunities for children to think about how to structure their writing and ensure the parts of their writing fit together. There is a real focus here on considering whether a text will make sense to the reader, also helping children to avoid ambiguity.

Skills to writing

● Cohesion focus
Using a wide range of texts, use discrete sessions to focus on different aspects of cohesion, looking at pronoun use, repetition, paragraph linking and so on, considering each aspect separately. This study needs to be ongoing and varied, with you demonstrating how to look at texts and pick them apart to find these features.

● Single-sentence summaries
Once a text has been read and discussed, challenge the class to create a single-sentence summary of it. This can be done for a short news piece right up to a whole novel, and has two important functions. Firstly, especially for shorter texts, it forces children to really consider the purpose of the text and the information it displays. Also – and the longer the text the more this happens – it challenges children to avoid ambiguity in their single-sentence summary while capturing the essence of a text.

● Avoiding ambiguity
In a sense, ambiguity is the opposite of cohesion, and in most cases (though not all) is not desirable in texts. An interesting exercise is to write ambiguous statements for the whole class to read (for example, *I'll meet you at eight, although I haven't done my homework.*) and consider where the ambiguity arises, clarifying the text (for example, *I'll meet you at eight if I have done my homework.*). This can also be done using children's own work to collectively improve such issues.

● Know your adverbials
The concept that other words and phrases can act as adverbs is difficult to grasp. To encourage understanding, use adverbials provided within this chapter, or others, and look at how the adverbials can be placed in sentences, writing them with the adverbials in front of or following the verb, considering how meaning remains the same but tone and flow is altered.
Example one: *He wore a helmet from that day onwards, whenever he rode his bike.*
Example two: *From that day onwards, he wore a helmet whenever he rode his bike.*

Activities

● Photocopiable page 122 'Fact files'
This photocopiable sheet presents a template for creating a fact file using the organisational features children will be familiar with. (Importantly, it has the same layout as the sample text on poster page 103 'Structuring texts'.) Although children will need to research their chosen person, animal or object, it is important that they make rough notes initially, as copying down information will not fulfil the learning aims. This can easily be incorporated into a class topic or focus, combining all children's work to produce a class mini-encyclopedia of fact files.

● Photocopiable page 123 'My cohesion'
This activity is designed to challenge children to think explicitly about their use of cohesive devices. As such, it is challenging and may need rough planning too, as well as prior modelling. Children are asked to write a short story (three paragraphs are suggested but this can obviously be extended), and to simultaneously identify and list three cohesive devices they have used. (Again, more can be listed if required.) You may wish to display examples of devices to aid this work, or even to scaffold children's learning by providing paragraph starters and particular adverbials and pronouns that might help. The activity can differentiate itself, with more confident children being encouraged to consider 'synonyms' and 'ellipses' if this is considered appropriate. Note that 'synonyms' and 'ellipses' are covered in greater detail in Year 6.

- **Excuses**

Encourage children to imagine that this morning everyone was late for school. Using cohesive devices, ask them to write excuses that are elaborate and imaginative – and impress the angry teacher by using the full range of cohesive devices. *On the way to school something happened, and then something else, and just then… and after that….* Once they have written up these paragraphs of imaginative tales, children can practise saying them to a po-faced teacher. For inspiration, try reading Jill Murphy's *On the Way Home* (Macmillan Children's Books), a classic of tall-story making.

- **Help the reader**

Challenge more confident learners to write their own 'Guide to cohesive writing', which they might take home with them and try on an appropriate adult or sibling. Explain that their guide should do as it preaches, and be well-structured and cohesive. They should plan the sections they will have and the features they will use, incorporating subheadings, lists, and so on, and perhaps examples of cohesive fiction writing that they have also generated.

- **Writing across the curriculum**

In studying other subjects, particularly humanities and science, children will need to write a range of text-types. Using the knowledge from this chapter should help them to plan texts that are well-structured and lucid, with ample opportunities to use headings and lists. In preparing their written work include cohesion and flow in checklists for them to review and amend their plans before they start working.

Digital content

On the digital component you will find:
- Printable versions of both photocopiable pages.

Name:

Helping the reader

Fact files

■ Research something that interests you. It might be an animal, a machine or a person you admire. Use the template below to create a fact file.

picture

list of facts – use numbers or bullets

heading

text – this might have paragraphs and subheadings

Helping the reader

My cohesion

■ Use this template to write a short piece of fiction. There is space for three paragraphs but you can write more on a separate sheet if you need to.
■ For each paragraph also write all the cohesive words and phrases that you have used in the boxes next to it. Try to identify three per paragraph.

Chapter 6

Punctuation

Introduction

This chapter introduces children to the concept of parenthesis and goes on to develop their understanding of this as well as reviewing punctuation they will already have encountered. This will help them to write more effectively through considered use of appropriate punctuation. For further practice, please see the 'Punctuation' section of the Year 5 workbook.

Poster notes

Parenthesis (page 125)
This poster provides a simple explanation of what 'parenthesis' is. It is important for children to understand the three different variations, as it is frequently misunderstood that the term 'parenthesis' refers to brackets only, the correct word for this being 'parentheses'.

Punctuation notes (page 126)
This poster is a useful reference for children as to the technical functions of many types of punctuation (colons, semicolons and hyphens are not included as they will be introduced in Year 6 – note that hyphens are not the same as dashes). It may be helpful to laminate some copies and have them available to groups when they are writing.

In this chapter

Brackets, dashes and commas page 127	Identify and begin to understand the use of brackets, dashes or commas to indicate parenthesis.
Using parenthesis in writing page 131	Develop the use of parenthesis in writing.
Commas in writing page 135	Use commas to clarify meaning or avoid ambiguity.
Revisiting punctuation page 139	Revisit punctuation.
Refining punctuation in writing page 143	Consolidate and extend the use of punctuation in writing.

Vocabulary

Children should already know:
apostrophe, comma, inverted commas, full stop, question mark, exclamation mark, punctuation, sentence

In Year 5 children need to know:
parenthesis, bracket, dash, ambiguity

Punctuation

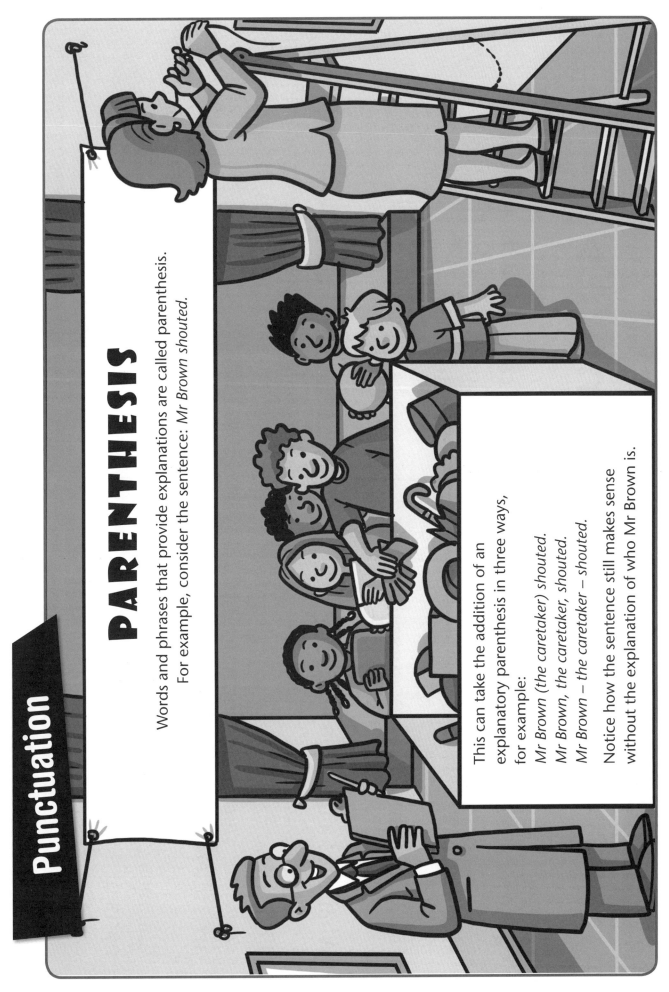

PARENTHESIS

Words and phrases that provide explanations are called parenthesis. For example, consider the sentence: *Mr Brown shouted.*

This can take the addition of an explanatory parenthesis in three ways, for example:

Mr Brown (the caretaker) shouted.
Mr Brown, the caretaker, shouted.
Mr Brown – the caretaker – shouted.

Notice how the sentence still makes sense without the explanation of who Mr Brown is.

Punctuation

Punctuation notes

Capital letter at start of sentence.

Dash to tag bits on to a sentence—like this.

Full stop to end a sentence.

What does a question mark do?

The teacher said "*Inverted commas demarcate speech.*" (Sometimes they are called speech marks, too.)

Commas are used to separate certain parts of sentences, making them easier to read and avoiding ambiguity.

Brackets can be used for additional information (like the earlier speech marks note).

Wow – exclamation mark!

Apostrophes show a noun's possession or they show contraction – they mustn't be put in the wrong place.

Don't forget that commas, brackets and dashes can all be used for parenthesis. For example:
Mr Brown (the caretaker) shouted.
Mr Brown, the caretaker, shouted.
Mr Brown – the caretaker – shouted.

Brackets, dashes and commas

Objective

Identify and begin to understand the use of brackets, dashes or commas to indicate parenthesis.

Background knowledge

Parenthesis is a word, clause or phrase inserted into a complete sentence to provide additional information. The sentence would still make sense and be grammatically correct without the parenthesis. Parenthesis can be demarcated with commas, brackets or dashes.

Activities

● **Photocopiable page 128 'Parenthesis'**
This activity both explains and investigates the use of parenthesis. Ensure that the term 'parenthesis' has been introduced – poster page 125 'Parenthesis' may be useful.

● **Photocopiable page 129 'Using parenthesis'**
Part of the process of understanding when and how to use parenthesis within a sentence involves knowing the type of clause that is demarcated in this way. This activity explores the type of clause that will be placed in specific sentences. Tell the children to read the sentences before inserting the clauses. Ask: *Do they make sense without the information in parenthesis?*

● **Photocopiable page 130 'Slot it in'**
Ask the children to look at each sentence and see if they can spot where the extra information provided in parenthesis can be placed. Point out to the children the different ways of indicating the extra information (such as brackets, dashes or commas). It is important that they read each new sentence as they construct it to check that it still makes sense.

Further ideas

● **Rewriting sentences:** Reviewing some recent pieces of their writing, the children can look at some of the sentences they have used to see if they could have given more information. Could they have used parenthesis to identify or explain something more clearly?

● **Clause snatching:** Invite children to look at long sentences from stories. They can write these on a whiteboard or sheet of paper, and then look at the clauses they can remove that leave the sentence intact. In doing so, they should consider if they were using parenthesis correctly.

● **Meet my family:** Ask the class to write a sentence about each member of their family, then rewrite each one adding a parenthesis to provide additional – but non-essential – information.

● **Consequences Xtra:** In pairs or groups use the usual structure of the game 'Consequences' to generate the usual scenarios that consequences can provide. Once finished, challenge children to embellish their mini-stories using parenthesis. For example: *Donald Duck – who never goes swimming – met Mini Mouse, who was wearing a red dress, in the park.*

Digital content

On the digital component you will find:
● Printable versions of all three photocopiable pages.
● Answers for all three photocopiable pages.
● Interactive versions of 'Parenthesis' and 'Using parenthesis'.

Brackets, dashes and commas

Parenthesis

These sentences each contain a middle section that adds something to the main clause of the sentence.
So, in the sentence:

> The dog, who had caught a bad dose of fleas, scratched and scratched.

The section between commas tells us something about the dog and could be removed, leaving a sentence that still makes sense.
Putting words between commas is called 'parenthesis'. This can also be done using two dashes or brackets, like this:

> The dog – who had caught a bad dose of fleas – scratched and scratched.
> The dog (who had caught a bad dose of fleas) scratched and scratched.

■　Look at these sentences and decide which words should be in parenthesis. Shade over them in colouring pencil, then put commas, dashes or brackets on either side of them.

My sister who starts Brownies today has new shoes.

The green door which has no window needs repairing.

My mum realising she had no bus fare had to go back home.

Last night the school caretaker who lives in a house beside the school had to repair two broken windows.

On Tuesday after school has finished I am going swimming.

The chocolate cake which my mum had hidden had been eaten up.

My friend the one that lives in Scotland is coming to stay for a holiday.

After school if it isn't raining we are going for a picnic.

My brother without thinking about it jumped off the top diving board.

Today my bicycle which hasn't worked for weeks is going to the repair shop.

Brackets, dashes and commas

Using parenthesis

■ These clauses fit into the sentences below using parenthesis.

the one with the puncture
my mum's sister
the green one
my mother's mother
the new one
the one with the bandaged paw
the big old building
the one in the village

■ Try to put the right clause in the right sentence.

My dog, _____, needs to see a vet.

My gran, _____, has got false teeth.

Our school (_____) is getting knocked down.

My sister's bike – _____ – needs repairing.

Today the computer, _____, broke down.

Aunty Lou (_____) is visiting us.

The old oak tree (_____) blew down in the storm.

My toothbrush – _____ – has lost its bristles.

 Scholastic English Skills
Grammar and punctuation: Year 5 **129**

Name:

Slot it in

Each of these sentences has a slip of information in parenthesis. The slip can be inserted somewhere in the sentence.

■ Cut out the sentence strip and the slip. For example:

The big bull escaped and ran through the village.	, the fiercest on the farm,

■ Mark the sentence at the point where you think the slip belongs, and then read the whole sentence. For example:

The big bull	, the fiercest on the farm,	escaped and ran through the village.

■ Does it read well? Does it sound right?
■ Cut the sentence strip in two at the right point; place the slip in the space in-between and stick the new longer sentence onto a sheet of paper.
■ Now do the same with these sentences and slips.

Laura starts Nursery today.	, my sister,
My friend is a great swimmer.	– called Sam Watson –
My brother dressed smartly today.	(who is usually a scruff)
For my birthday I want a party.	– in March –
Our poplar tree blew over in the storm.	, the one on the school field,
Ms Shell repaired our light switch.	, our school caretaker,
I might join the school chess team.	– if I get a chance –
When she gets home my mum has a sleep.	(worn out and tired)

Using parenthesis in writing

Objective

Develop the use of parenthesis in writing.

Background knowledge

This section aims to extend the learning from the previous one – Brackets, dashes and commas – so that children become more familiar with the terminology while incorporating parenthesis more freely into their writing. Throughout the section, stress to the class that they must re-read their work, pausing appropriately and using suitable intonation, to check that their text flows easily and has meaning. You could provide a range of modelled examples (correct and incorrect) to demonstrate this.

Activities

● **Photocopiable page 132 'Punctuation, please!'**
Ask the children to rewrite each sentence, inserting parenthesis and adding any other punctuation to make each sentence complete. You can decide whether to focus only on parenthesis, or to use this to renew awareness of other punctuation (only minor additional punctuation is required). Remember to challenge children to use commas, dashes and brackets.

● **Photocopiable page 133 'People power'**
This activity presents simple profiles for six different people, with only brief information provided. Invite children to create two or more sentences including parenthesis for each person. You may prefer simply to display the characters large on the whiteboard and do this initially as an oral exercise, perhaps with children creating sentences and challenging others to identify the parenthesis.

● **Photocopiable page 134 'Critical information'**
This activity presents a passage of text that has lots of additional information provided in parenthesis. The challenge is for children to edit it and re-present it in as succinct a form as possible, in many cases (but not all) removing parenthesis and/or rephrasing information.

Further ideas

● **Redrafting:** Ask children to look at their own writing and to record extracts that could have been presented as sentences including parenthesis. Can they rewrite their sentences in this way?

● **Too much information!:** Challenge the class to write sentences about as many objects in the room as possible, using parenthesis to provide additional information. In reviewing each other's work, ask them to consider whether the information in parenthesis is useful or useless. For example, contrast: *The door, which is brown, closes slowly* with *The pencil sharpener (which is blunt) is in the drawer.* The latter has significant information.

● **Speaking aside:** In drama or oral work, develop the concept of the aside as a way of presenting additional information. This is often delivered with one hand to the side of the mouth, suggesting that it is select information. For example: *The prince – who will be here in five minutes – is not expecting us to be here.* Direct the speaker to use a gesture while adding the parenthesis.

Digital content

On the digital component you will find:
● Printable versions of all three photocopiable pages.
● Answers to 'Punctuation, please!' and 'Critical information'.
● Interactive version of 'Punctuation, please!'.

Name:

Punctuation, please!

■ Rewrite these sentences, inserting the punctuation that they need to make sense. Each one needs commas, dashes or brackets for parenthesis, as well as the usual punctuation for a complete sentence.

on Tuesday the day after tomorrow it is lornas birthday and weve been invited to her party

sam my uncle is starting work today at my grandads cafe

the cake which was covered in icing had been made especially for the king

my auntie the one with the motorbike is taking me to the football match

in the largest city in England London many different languages are spoken

in some countries they love football the world's most popular sport less than cricket

sadly she put her running shoes which she had used in so many races into the cupboard and never touched them again

Using parenthesis in writing

People power

■ Look at the profiles of these six people. Write two or three sentences with parenthesis for each of them.

Timothy Tomkins
Age 9
Goes to school
Has 1 sister
Loves porridge

Edwina Fry
Age 59
Is a doctor
Has 3 children
Loves coffee

James Gonzalez
Age 1
Is not at nursery
Has 3 sisters
Loves his mummy

Tina Tomkins
Age 11
Goes to school
Has 1 brother
Loves marmite

Samina Shah
Age 19
Is a student
Is an only-child
Loves strawberries

Tom Tomkins
Age 34
Is a carpenter
Has 2 children
Loves tea

Name:

Critical information

Sometimes it is important to sort out the essential facts from the additional information. Information put in parenthesis is not necessary for a sentence to make sense, but it still may be important.

■ Imagine you work for a private detective agency. Your job is to take reports and reduce them to the essential facts. Look at the report below and rewrite it to show only the critical information. Your finished piece should be shorter than the text you can see here.

Today I have been investigating Mr T. Leaf, a suspected bank robber, who police think is responsible for some recent robberies. He lives in Alby Avenue (which is a lovely tree-lined street) with his wife and two children. I suspect that his children – who both go to the local primary school – help him with his robberies in the evenings, when they act as lookouts. But it is Mrs Leaf, who has blonde hair and blue eyes, who is the mastermind. This morning she drove into town, after she had dropped the little Leafs off at school, and went to the post office (the same one that I go to) on Posh Street. Once she was inside she opened her shopping bag – made of real leather – and got out several brown paper bags. She handed these over to the lady in the post office, the one that looks like my Auntie Mabel, who looked very happy to see her. I suspected that she might be part of their gang too, so I went and asked her for a first class stamp (which I needed anyway for my cousin's birthday) and she didn't know the price!

Commas in writing

Objective

Use commas to clarify meaning or avoid ambiguity.

Background knowledge

Commas can be used in writing:
- to separate items in small lists within a sentence
- to demarcate parenthesis
- to separate clauses
- in direct speech.

Developing children's awareness is important for ensuring that their writing is not ambiguous. Be sure to explain and exemplify to the children how to achieve ambiguity in writing.

Activities

● **Photocopiable page 136 'Using commas'**
Children must match the explanations of comma usage with an example. This can be used as a whole-class activity to focus on the grammatical aspects and terms involved. It can be extended by creating new sentences for each of the different uses.

● **Photocopiable page 137 'Start making sense'**
Children are presented with a range of sentences without commas in them. Invite them to decide where to insert the commas, and to explain what role the commas are playing in each of their sentences. This is perhaps a trickier activity than it first appears, but is excellent for helping children to see how easily intended meaning can become confused or ambiguous if sentences are not properly demarcated. You may wish to introduce this with the whole class, reading each sentence without pauses in its incorrect state.

● **Photocopiable page 138 'Dead worried!'**
Arrange the children into groups of four to six. Ask them to work in pairs, and to use a coloured pencil to insert the thirteen commas into the passage. They can then compare their completed sheets with another

pair's (copying their commas onto the other pair's sheet using a different colour). Encourage them to discuss any differences of opinion. Round off the activity by telling the children where the commas should be placed in the original text.

Further ideas

● **Comma spotting:** Carrying on from the 'Dead worried!' activity, ask the class to identify comma use in their own reading books, noting examples of different uses as appropriate.
● **Ambiguity:** Display an ambiguous sentence or statement at the start of each day, such as *Children make delicious snacks*, to focus children on how ambiguity can be in meaning, not just commas. It can also be fun – lots of such witty ambiguities are easy to source on the internet.

Digital content

On the digital component you will find:
- Printable versions of all three photocopiable pages.
- Answers for all three photocopiable pages.
- Interactive version of 'Using commas'.

Name:

Commas in writing

Using commas

■ Draw lines to match the explanations for uses of commas to the correct examples.

Explanations for comma uses

Examples

Commas are usually used to separate items in small lists within a sentence.

Commas are sometimes used to demarcate parenthesis.

Commas are often used in direct speech.

Commas are usually used to separate clauses.

My favourite armchair, the one with saggy cushions, has got a hole in it.

They travelled to Cardiff, where they had lunch and visited the castle.

They started the day with a breakfast of scrambled eggs, bacon, sausage and toast.

"Be quiet," he said, "and stay in your seats!"

PHOTOCOPIABLE

Commas in writing

Start making sense

■ All of the sentences below have had their commas removed. You must add the commas to ensure each sentence make sense. In each box, write what role the commas are doing, such as showing parenthesis.

The car which was red stopped suddenly.

"Hello" she said "it's nice to meet you."

He scored top marks however he has been copying.

The window had been smashed making the room cold.

They packed sweets torches books and card games for their sleepover.

Her cat the one that slept most of the time scratched me.

Name:

Commas in writing

Dead worried!

■ Replace **fourteen** missing commas (including the title).

Calm down Mr King

Mr King is my school teacher. He's OK even if he gets a bit worked up some days.

Today is one of those days. Behind his steaming glasses his eyes are glazed with

emotion.

"So Year 6 if we are going to produce some good creative writing for you to

take home to your suffering parents we've got to have creative input. Do you

know what input means Corky?"

Corky my best mate blinks and says "Input. Like output but different. Yes. Sure.

Input. Let me think. Um. Putting something in. Yeah."

Mr King glares at him. "That was a lucky guess Corky." He removes his glasses

wipes them blots the damp patch on his forehead and breathes heavily.

Revisiting punctuation

Objective

Revisit punctuation.

Background knowledge

Children should now be familiar with, and have access to explanations and examples for all of the following punctuation marks: apostrophe, comma, inverted commas, full stop, question mark, exclamation mark, bracket, dash. They should know that some of these have more than one use (such as commas). Note that the following items are not expected to have been covered at this stage: colon, semicolon and hyphen as they are introduced in Year 6.

Activities

● **Photocopiable page 140 'Explain yourself'**
This is a straightforward activity for children to further familiarise themselves with all of the punctuation marks they have learned so far (including in earlier school years). It may be it beneficial to work through this orally with the whole class before asking children to complete the photocopiable sheet.

● **Photocopiable page 141 'Sentence looping'**
The correct use of punctuation involves being familiar with certain aspects of sentences. In this activity children use colouring pencils to demarcate some of the significant aspects of sentences that are punctuated in particular ways. Their looping of speech develops awareness of where they should place inverted commas. The looping of clauses develops an understanding of where they should place clause-separating items of punctuation, such as commas. Awareness of questions develops use of the question mark.

● **Photocopiable page 142 'Punctuation spotting'**
This photocopiable sheet provides a framework for children to examine a text they are familiar with, such as their current reading book, and identify uses of different punctuation marks. They are required to write down the relevant sentence from the book, and then explain why the punctuation is being used. As well as revising all punctuation marks, the different uses of commas are also covered, and children may need to review different pages or texts to find examples of all of these.

Further ideas

● **Carpet talk:** During class discussions, explain to the class that, over the coming week, they are occasionally going to stop a speaker after they have said something and ask the class to figure out how that act of speaking would be recorded in an account of the event written later on. For the next week, every so often, after a child has said something like *Can I take the register downstairs?* stop the class and ask them to model the event as a sentence on the board (for example: *Fozia asked, "Can I take the register downstairs?"*).

● **Dialogue:** Ask the children to find passages in novels in which a group of characters are speaking and to try acting out the passage, each taking a role and saying aloud the words ascribed to that character. Point out to the class that they can find the lines for their drama by looking for the spoken words demarcated in the text.

Digital content

On the digital component you will find:
● Printable versions of all three photocopiable pages.
● Answers to 'Explain yourself' and 'Sentence looping'.
● Interactive version of 'Sentence looping'.

Name:

Revisiting punctuation

Explain yourself

■ Name each of the punctuation marks below, and then explain what its job is. Full stop has been done for you.

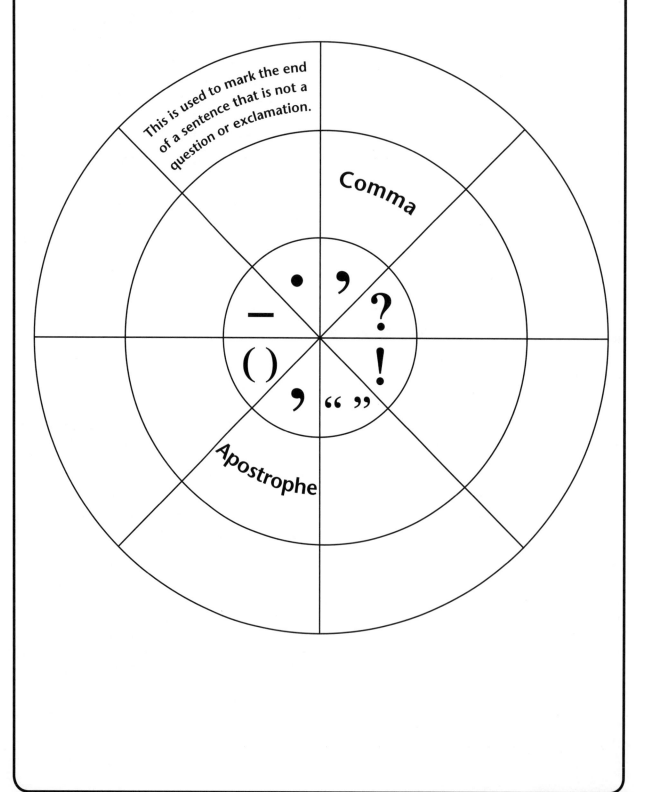

PHOTOCOPIABLE

Revisiting punctuation

Sentence looping

■ Look at the unpunctuated sentences below and circle different bits in different colours.

- Circle words that are spoken in red.
- Circle subordinate clauses in green.
- Circle sentences that are questions in blue.

louise said help me do this jigsaw

is it time for dinner

on Tuesday after school finishes we go to the club

lola said lets go ice skating next friday

the teacher said its time for our spelling test

we went to blackpool which was a big treat

can you play a cd on this player

our class decided after a lot of thinking to have a party

Name:

Revisiting punctuation

Punctuation spotting

■ Use this sheet to record examples of different punctuation marks from books you know. Write the sentence from your book and circle the punctuation that you are interested in. Explain why the punctuation has been used.

Punctuation mark	Example sentence	Explanation
. **Full stop**		
? **Question mark**		
! **Exclamation mark**		
" " **Inverted commas**		
' **Apostrophe**		
() **Brackets**		
— **Dash**		
, **Comma**		

■ There are several different jobs that commas do. Find an example for each type. Write these on a separate piece of paper.

Refining punctuation in writing

Objective

Consolidate and extend the use of punctuation in writing.

Writing focus

Building on previous activities, this section encourages children to use a variety of punctuation for different purposes in their writing.

Skills to writing

● **Cut and embed**

Ask children to look for appropriate sentences in their own writing, write the original on a strip of paper, and then see a point where they could cut the sentence and add a parenthesis. For example, if they have written *Yesterday we went to the pantomime*, they might write *Yesterday, because we had been such a great class, we went to the pantomime*. Not forgetting to use dashes and brackets as well as commas of course.

● **Slot in**

As they both read and write shared texts, children should be looking out for instances when something can be slotted in. This could be an additional piece of information, for example, *Mr Hawkins set off the fire alarm*, becomes *Mr Hawkins, our caretaker, set off the fire alarm*. Or an aside of extra detail: *Mr Hawkins, screaming and flinging his arms, set off the fire alarm*. As they add these they can use commas, brackets and dashes for parenthesis.

● **Parenthesis asides**

The use of commas, brackets or dashes for parenthesis can be developed by using them to insert asides in children's narrative writing. These are the little bits of insight that can be given into a character's behaviour. Like all tips of this nature the trick is not to overdo it. When writing about an action performed by a character (*I went to the door and looked through the letter box*), children can slot in a parenthesis that gives some insight

into the thoughts and feelings of the character. This is sometimes called the 'inner voice' – those features of the story that would not have been seen by an observer (*I went to the door and, not wanting to be seen, looked through the letter box*).

● **Colour coding**

As children reflect on their writing, they may be able to use the sort of colour coding that was used on photocopiable page 141 'Sentence looping'. When editing previous pieces of writing, ask them to look for at least two features they can either highlight as included or that could have been used. They can use different colours for these – so speech punctuation can be ticked in red and use of question marks in blue. One of the main functions performed here is to send children back to their work, looking for more than one feature of punctuation or grammar. The colours provide a guide in such twin-tracked activities.

● **Punctuation awareness**

As with the punctuation spotting exercise on photocopiable page 140 'Explain yourself', use regular opportunities to focus purely on punctuation, thinking particularly on how it affects the flow of text. Reading aloud is best for this, which also helps children to develop skills and understanding in allowing punctuation to guide their intonation and pacing.

Activities

● **Photocopiable page 145 'Inserting parenthesis'**

This activity encourages children to lengthen sentences to ridiculous degrees. They may wish to write their additions in various coloured felt-tipped pens to give the whole thing a bit of colour, highlighting parenthesis in particular. You could model this during whole-class work, in particular helping children to get started from a very basic initial sentence.

● **Photocopiable page 146 'Timothy Tomkins' homework'**

Poor Timothy – he's really having trouble with his punctuation, and needs help. Ask the children to analyse sentences that Timothy has written, explain his errors, and then write each one out correctly.

Write on

● Freeze-frame writing

Freeze-frame is a technique often used to encourage children in their reading. Different children take on the role of a character and create a frozen tableau of a moment in a story. They can then unpick and share the thoughts and feelings they think are going on in that character's mind at this point in time. This technique can also be used to enrich writing. Children can form small groups and a child who is putting together a piece of narrative writing can ask different children to take up the positions of characters in their planning. Having created such a freeze-frame they can then unpick the various thoughts and feelings that their friends will end up injecting into their ideas for writing. This can result in expansiveness in children's writing about the 'inner voice' of characters for use in 'Parenthesis asides' (see 'Skills to writing').

● Details

Using the idea of parenthesis, children can revisit writing they have done, seeing where they could insert parenthesis that adds an extra bit of detail. If, in a story about being late, they wrote *My teacher was very angry*, they could insert parenthesis that says something about the character – maybe a detail about his attitude to lateness or her appearance that morning (*My teacher – who had turned a tomato shade of temper – was very angry*). Children can be guided to see parenthesis as a way of adding an element of fun and character to their writing.

● Captain Comma

This is a light-hearted activity aimed at consolidating children's awareness of the different possible uses of commas (as outlined on photocopiable page 136 'Using commas'). The challenge is for children to write a story in a particular style or genre but ensuring that they have at least one correct example of each type of comma use. With work completed, children should review each other's work (individually or as a whole class), and decide whether Captain Comma would approve. Are all uses covered, and are they correct?

● Top marks

Provide a range of tasks that require different punctuation. Obviously a report often requires headings, subheadings and lists more than fiction does, but there are other literary techniques too. For example, tension and pace can often be created using very short sentences with minimal punctuation; dialogues tend to be more succinct too, with a greater focus on correct comma, and inverted comma, usage. A Q&A of wild facts can reinforce the use of question and exclamation marks. Finally, looking at newspaper reports is great for honing understanding of the relationship between words and punctuation, where maximum meaning needs to be conveyed in minimum space. Child-friendly newspapers usually excel at this.

Digital content

On the digital component you will find:
● Printable versions of both photocopiable pages.
● Answers to 'Timothy Tomkins' homework.

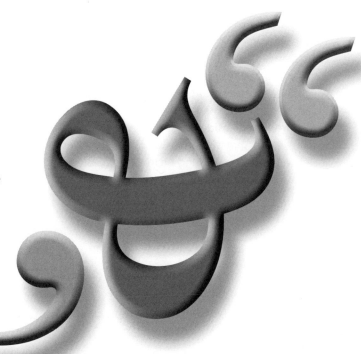

Inserting parenthesis

■ Cut up these sentences and add parenthesis and other words to extend them. For example:

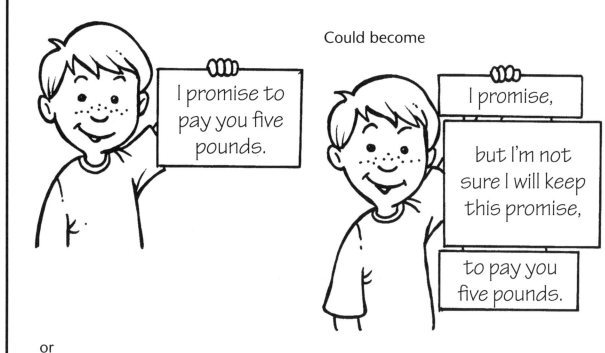

Could become

or

I am going home.	I will make you a drink.
I like cheese.	I told them.

Name:

Timothy Tomkins' homework

■ Timothy is really struggling with his punctuation homework. Explain any problems in each of his sentences and then write them down correctly for him.

1. I walk to school every morning

Explanation: <u>You must finish a sentence with a full stop.</u>

Correction: <u>I walk to school every morning.</u>

2. Can I have a sandwich please.

Explanation: _____

Correction: _____

3. Please be quiet said the teacher I need to concentrate.

Explanation: _____

Correction: _____

4. My bedroom which is next to the bathroom is my favourite place.

Explanation: _____

Correction: _____

5. I cant find my glasses so I am wearing Joes instead.

Explanation: _____

Correction: _____

6. Ouch shouted Jenny who was usually brave when the ball hit her.

Explanation: _____

Correction: _____

Subject knowledge

1. Preliminary notes about grammar

Grammar involves the way in which words of different types are combined into sentences. The explanatory sections that follow will include definitions of types of word along with notes on how they are combined into sentences.

Three preliminary points about grammar:

- Function is all-important. Where a word is placed in relation to another word is crucial in deciding whether it is functioning as a verb or a noun. For example, the word 'run' will often be thought of as a verb. However, in a sentence like *They went for a run*, the word functions as a noun and the verb is 'went'.
- There are some consistencies in the way spelling is linked to grammar. For example, words like 'play' and 'shout' have the 'ed' ending to make past tense verbs, 'played' and 'shouted'. Adjectives like 'quick' and 'slow' take a 'ly' ending to make adverbs like 'quickly' and 'slowly'. There are exceptions to these rules but such consistencies can still prove useful when it comes to understanding the grammar of sentences.
- Nothing is sacred in language. Rules change over time; the double negative has gained currency, and regional variation in accent and dialect is now far more valued than has been the case in the past. The rules of grammar that follow are subject to change as the language we use lives and grows.

2. Words and functions

Grammar picks out the functions of words. The major classes or types of word in the English language are:

Noun
The name of something or someone, including concrete things, such as 'dog' or 'tree', and abstract things, such as 'happiness' or 'fear'.

Pronoun
A word that replaces a noun. The noun 'John' in *John is ill* can be replaced by a pronoun 'he', making *He is ill*.

Verb
A word that denotes an action or a happening. In the sentence *I ate the cake* the verb is 'ate'. These are sometimes referred to as 'doing' words.

Adjective
A word that modifies a noun. In the phrase *the little boat* the adjective 'little' describes the noun 'boat'.

Adverb

A word that modifies a verb. In the phrase *he slowly walked* the adverb is 'slowly'.

Preposition

A word or phrase that shows the relationship of one thing to another. In the phrase *the house beside the sea* the preposition 'beside' places the two nouns in relation to each other.

Conjunction

A word or phrase that joins other words and phrases. A simple example is the word 'and' that joins nouns in *Snow White and Doc and Sneezy*.

Determiner

Determiners appear before nouns and denote whether the noun is specific (*give me the book*) or not (*give me a book*). Note that 'the' (definite article) and 'a' or 'an' (indefinite articles) are the most common types of determiner.

Interjection

A word or phrase expressing or exclaiming an emotion, such as 'Oh!' and 'Aaargh!'
The various word types can be found in the following example sentences:

Lou	saw	his	new	house	from	the	train.
noun	verb	pronoun	adjective	noun	preposition	article	noun
Yeow!	I	hit	my	head	on	the	door.
interjection	pronoun	verb	pronoun	noun	preposition	article	noun
Amir	sadly	lost	his	bus fare	down	the	drain.
noun	adverb	verb	pronoun	noun	preposition	article	noun
Give	Jan	a	good	book	for	her	birthday.
verb	noun	article	adjective	noun	conjunction	pronoun	noun

The pages that follow provide more information on these word classes.

Nouns

There are four types of noun in English.

> A **noun** is the name of someone or something.

Common nouns are general names for things. For example, in the sentence *I fed the dog*, the noun 'dog' could be used to refer to any dog, not to a specific one. Other examples include 'boy', 'country', 'book', 'apple'.

Proper nouns are the specific names given to identify things or people. In a phrase like *Sam is my dog* the word 'dog' is the common noun but 'Sam' is a proper noun because it refers to and identifies a specific dog. Other examples include 'Wales' and 'Amazing Grace'.

Collective nouns refer to a group of things together, such as 'a flock (of sheep)' or 'a bunch (of bananas)'.

Abstract nouns refer to things that are not concrete, such as an action, a concept, an event, quality or state. Abstract nouns like 'happiness' and 'fulfilment' refer to ideas or feelings which are non-countable; others, such as 'hour', 'joke' and 'quantity' are countable.

Nouns can be singular or plural. To change a singular to a plural the usual rule is to add 's'. This table includes other rules to bear in mind:

If the singular ends in:	Rule	Examples
'y' after a consonant	Remove 'y', add 'ies'	party → parties
'y' after a vowel	add 's'	donkey → donkeys
'o' after a consonant	add 'es'	potato → potatoes
'o' after a vowel	add 's'	video → videos
an 's' sound such as 's', 'sh', 'x', 'z'	add 'es'	kiss → kisses dish → dishes
a 'ch' sound such as 'ch' or 'tch'	add 'es'	watch → watches church → churches

Pronouns

There are different classes of pronoun. These are the main types:

> A **pronoun** is a word that stands in for a noun.

Personal pronouns refer to people or things, such as 'I', 'you', 'it'. The personal pronouns distinguish between subject and object case ('I/me', 'he/him', 'she/her', 'we/us', 'they/them' and the archaic 'thou/thee').

Reflexive pronouns refer to people or things that are also the subject of the sentence. In the sentence *You can do this yourself* the pronoun 'yourself' refers to 'you'. Such pronouns end with 'self' or 'selves'. Other examples include 'myself', 'themselves'.

Possessive pronouns identify people or things as belonging to a person or thing. For example, in the sentence *The book is hers* the possessive pronoun 'hers' refers to 'the book'. Other examples include 'its' and 'yours'. Note that possessive pronouns never take an apostrophe.

Relative pronouns link relative clauses to their nouns. In the sentence *The man who was in disguise sneaked into the room* the relative clause 'who was in disguise' provides extra information about 'the man'. This relative clause is linked by the relative pronoun 'who'. Other examples include 'whom', 'which' and 'that'.

Interrogative pronouns are used in questions. They refer to the thing that is being asked about. In the question *What is your name?* and *Where is the book?* the pronouns 'what' and 'where' stand for the answers – the name and the location of the book.

Demonstrative pronouns are pronouns that 'point'. They are used to show the relation of the speaker to an object. There are four demonstrative pronouns in English 'this', 'that', 'these', 'those' used as in *This is my house* and *That is your house*. They have specific uses, depending upon the position of the object to the speaker:

	Near to speaker	Far away from speaker
Singular	this	that
Plural	these	those

Indefinite pronouns stand in for an indefinite noun. The indefinite element can be the number of elements or the nature of them but they are summed up in ambiguous pronouns such as 'any', 'some' or 'several'. Other examples are the pronouns that end with 'body', 'one' and 'thing', such as 'somebody', 'everyone' and 'anything'.

Person

Personal, reflexive and possessive pronouns can be in the first, second or third person.
- First-person pronouns ('I', 'we') involve the speaker or writer.
- Second-person pronouns ('you') refer to the listener or reader.
- Third-person pronouns refer to something other than these two participants in the communication ('he', 'she', 'it', 'they').

The person of the pronoun will agree with particular forms of verbs: 'I like'/'she likes'.

Verbs

The **tense** of a verb places a happening in time. The main tenses are the present and past.

> A **verb** is a word that denotes an action or a happening.

English does not have a discrete future tense. It is made in a compound form using a present tense ('I will', 'I shall' and so on) and an infinitive (for example *I will go to the shops*).

The regular past tense is formed by the addition of the suffix 'ed', although some of the most common verbs in English have irregular past tenses.

Present tense (happening now)	Past tense (happened in past)	Future (to happen in future)
am, say, find, kick	was, said, found, kicked	will be, will say, shall find, shall kick

Continuous verbs

The present participle form of a verb is used to show a continuous action. Whereas a past tense like 'kicked' denotes an action that happened ('I kicked'), the present participle denotes the action as happening and continuing as it is described (*I was kicking*, the imperfect tense, or *I am kicking*, the present continuous). There is a sense in these uses of an action that has not ended.

The present participle usually ends in 'ing', such as 'walking', 'finding', and continuous verbs are made with a form of the verb 'be', such as 'was' or 'am': *I was running* and *I am running*.

Auxiliary verbs

Auxiliary verbs 'help' other verbs – they regularly accompany full verbs, always preceding them in a verb phrase. The auxiliary verbs in English can be divided into three categories:

Primary verbs are used to indicate the timing of a verb, such as 'be', 'have' or 'did' (including all their variations such as 'was', 'were', 'has', 'had' and so on). These can be seen at work in verb forms like *I was watching a film*, *He has finished eating*, *I didn't lose my keys*.

Modal verbs indicate the possibility of an action occurring or the necessity of it happening, such as *I might watch a film*, *I should finish eating* and *I shouldn't lose my keys*.

The modal verbs in English are: 'would', 'could', 'might', 'should', 'can', 'will', 'shall', 'may', and 'must'. These verbs never function on their own as main verbs. They always act as auxiliaries helping other verbs.

Marginal modals, namely 'dare', 'need', 'ought to' and 'used to'. These act as modals, such as in the sentences *I dared enter the room*, *You need to go away* and *I ought to eat my dinner*, but they can also act as main verbs, as in *I need cake*.

Adjectives

The main function of adjectives is to define quality or quantity. Examples of the use of descriptions of quality include 'good story', 'sad day' and 'stupid dog'. Examples of the use of descriptions of quantity include 'some stories', 'ten days' and 'many dogs'.

> An **adjective** is a word that modifies a noun.

Adjectives can appear in one of three different degrees of intensity. In the table below it can be seen that there are 'er' and 'est' endings that show an adjective is comparative or superlative, though, there are exceptions. The regular comparative is formed by the addition of the suffix 'er' to shorter words and 'more' to longer words ('kind/kinder', 'beautiful/more beautiful'). The regular superlative is formed by the addition of the suffix 'est' to shorter words and 'most' to longer words. Note, however, that some common adjectives are irregular.

Nominative	Comparative	Superlative
The nominative is the plain form that describes a noun.	The comparative implies a comparison between the noun and something else.	The superlative is the ultimate degree of a particular quality.
Examples	**Examples**	**Examples**
long	longer	longest
small	smaller	smallest
big	bigger	biggest
fast	faster	fastest
bad	worse	worst
good	better	best
far	farther/further	farthest/furthest

Adverbs

Adverbs provide extra information about the time, place or manner in which the action of a verb happened.

> An **adverb** is a word that modifies a verb.

	
Manner Provides information about the manner in which the action was done.	Ali *quickly* ran home. The cat climbed *fearfully* up the tree.
Time Provides information about the time at which the action occurred.	*Yesterday* Ali ran home. *Sometimes* the cat climbed up the tree.
Place Provides information about where the action took place.	*Outside* Ali ran home. *In the garden* the cat climbed up the tree.

Variations in the degree of intensity of an adverb are indicated by other adjectives such as 'very', 'rather', 'quite' and 'somewhat'. Comparative forms include 'very quickly', 'rather slowly', and 'most happily'.

The majority of single-word adverbs are made by adding 'ly' to an adjective: 'quick/quickly', 'slow/slowly' and so on.

Prepositions

Prepositions show how nouns or pronouns are positioned in relation to other nouns and pronouns in the same sentence. This can often be the location of one thing in relation to another in space, such as 'on', 'over', 'near'; or time, such as 'before', 'after'.

> A **preposition** is a word or phrase that shows the relationship of one thing to another.

Prepositions are usually placed before a noun. They can consist of one word (*The cat* in *the tree...*), two words (*The cat* close to *the gate...*) or three (*The cat* on top of *the roof...*).

Determiners

There are different types of determiner:

> A **determiner** identifies whether a noun is known or unknown.

Articles are the most common type: 'the' (definite article) and 'a' or 'an' (indefinite article).

Possessives are often possessive pronouns such as 'my', 'your', 'our', but can also be nouns with an apostrophe, with or without an 's' (as in *Jane's car*, the *Prime Minister's speech*, the *girls' results*.)

Demonstratives are used to show the relation of the speaker to an object. There are four demonstrative pronouns in English 'this', 'that', 'these', 'those'. (See page 150.)

Quantifiers are used to express the quantity of a noun, for example: (indefinite quantity) 'some', 'many', 'several'; (definite quantity) 'every', 'both', 'all', 'four', 'seventy'.

Connectives

The job of a connective is to maintain cohesion through a piece of text.

> A **connective** is a word or phrase that links clauses or sentences.

Connectives can be:
- Conjunctions – connect clauses within one sentence.
- Connecting adverbs – connect ideas in separate sentences.

Conjunctions

Conjunctions are a special type of connective. There are two types: coordinating and subordinating.

Coordinating conjunctions connect clauses of equal weight. For example: *I like cake and I like tea.* Coordinating conjunctions include: 'and', 'but', 'or' and 'so'.

Subordinating conjunctions are used where the clauses of unequal weight, they begin a subordinate clause. For example: *The dog barked because he saw the burglar.* Subordinating conjunctions include: 'because', 'when', 'while', 'that', 'although', 'if', 'until', 'after', before' and 'since'.

Name of conjunction	Nature of conjunction	Examples
Addition	One or more clause together	We had our tea *and* went out to play.
Opposition	One or more clauses in opposition	I like coffee *but* my brother hates it. It could rain *or* it could snow.
Time	One or more clauses connected over time	Toby had his tea *then* went out to play. The bus left *before* we reached the stop.
Cause	One or more clauses causing or caused by another	I took a map *so that* we wouldn't get lost. We got lost *because* we had the wrong map.

Connecting adverbs

The table below provides the function of the adverbs and examples of the type of words used for that purpose.

Addition	'also', 'furthermore', 'moreover', 'likewise'
Opposition	'however', 'never the less', 'on the other hand'
Time	'just then', 'meanwhile', 'later'
Result	'therefore', 'as a result'
Reinforcing	'besides', 'anyway'
Explaining	'for example', 'in other words'
Listing	'first of all', 'finally'

3. Understanding sentences

Types of sentence

The four main types of sentence are declarative, interrogative, imperative and exclamatory. The function of a sentence has an effect on the word order; imperatives, for example, often begin with a verb.

Sentence type	Function	Examples
Declarative	Makes a statement	The house is down the lane. Joe rode the bike.
Interrogative	Asks a question	Where is the house? What is Joe doing?
Imperative	Issues a command or direction	Turn left at the traffic lights. Get on your bike!
Exclamatory	Issues an interjection	Wow, what a mess! Oh no!

Sentences: Clauses and complexities
Phrases

A phrase is a set of words performing a grammatical function. In the sentence *The little, old, fierce dog brutally chased the sad and fearful cat*, there are three distinct units performing grammatical functions. The first phrase in this sentence essentially names the dog and provides descriptive information. This is a noun phrase, performing the job of a noun – 'the little, old, fierce dog'. To do this the phrase uses adjectives.

The important thing to look out for is the way in which words build around a key word in a phrase. So here the words 'little', 'old' and 'fierce' are built around the word 'dog'. In examples like these, 'dog' is referred to as the **headword** and the adjectives are termed **modifiers**. Together, the modifier and headword make up the noun phrase. Modifiers can also come after the noun, as in *The little, old, fierce dog that didn't like cats brutally chased the sad and fearful cat*. In this example 'little, 'old' and 'fierce' are **premodifiers** and the phrase 'that didn't like cats' is a **postmodifier**. The noun phrase is just one of the types of phrase that can be made.

Phrase type	Examples
Noun phrase	The *little, old fierce dog* didn't like cats. She gave him *a carefully and colourfully covered book*.
Verb phrase	The dog *had been hiding* in the house. The man *climbed through* the window without a sound.
Adjectival phrase	The floor was *completely clean*. The floor was *so clean you could eat your dinner off it*.
Adverbial phrase	I finished my lunch *very slowly indeed*. *More confidently than usual*, she entered the room.
Prepositional phrase	The cat sat *at the top of* the tree. The phone rang *in the middle of* the night.

Notice that phrases can appear within phrases. A noun phrase like 'carefully and colourfully covered book' contains the adjectival phrase 'carefully and colourfully covered'. This string of words forms the adjectival phrase in which the words 'carefully' and 'colourfully' modify the adjective 'covered'. Together these words, 'carefully and colourfully covered', modify the noun 'book', creating a distinct noun phrase. This is worth noting as it shows how the boundaries between phrases can be blurred – a fact that can cause confusion unless borne in mind!

Clauses

Clauses are units of meaning included within a sentence, usually containing a verb and other elements linked to it. *The burglar ran* is a clause containing the definite article, noun and verb; *The burglar quickly ran from the little house* is also a clause that adds an adverb, preposition and adjective. The essential element in a clause is the verb. Clauses look very much like small sentences – indeed sentences can be constructed of just one clause: *The burglar hid*, *I like cake*.

Sentences can also be constructed out of a number of clauses linked together: *The burglar ran and I chased him because he stole my cake*. This sentence contains three clauses: 'The burglar ran', 'I chased him', 'he stole my cake'.

Clauses and phrases: the difference

Clauses include participants in an action denoted by a verb. Phrases, however, need not necessarily contain a verb. These phrases make little sense on their own: 'without a sound', 'very slowly indeed'. They work as part of a clause.

Simple, compound and complex sentences

The addition of clauses to single-clause sentences (simple sentences) can make multi-clause sentences (complex or compound sentences).

Simple sentences are made up of one clause, for example: *The dog barked*, *Sam was scared*.

Compound sentences are made up of clauses added to clauses. In compound sentences each of the clauses is of equal value; no clause is dependent on another. An example of a compound sentence is: *The dog barked and the parrot squawked*. Both these clauses are of equal importance: 'The dog barked', 'the parrot squawked'. Other compound sentences include, for example: *I like coffee and I like chocolate*, *I like coffee, but I don't like tea*.

Complex sentences are made up of a main clause with a subordinate clause or clauses. Subordinate clauses make sense in relation to the main clause. They say something about it and are dependent upon it, such as in the sentences: *The dog barked because he saw a burglar*; *Sam was scared so he phoned the police*.

In both these cases the subordinate clause ('he saw a burglar', 'he phoned the police') is elaborating on the main clause. They explain why the dog barked or why Sam was scared and, in doing so, are subordinate to those actions. The reader needs to see the main clauses to fully appreciate what the subordinate ones are stating.

Subject and object

The **subject** of a sentence or clause is the agent that performs the action denoted by the verb – *Shaun threw the ball*. The **object** is the agent to which the verb is done – 'ball'. It could be said that the subject does the verb to the object (a simplification but a useful one). The simplest type of sentence is known as the SVO (subject–verb–object) sentence (or clause), as in *You lost your way*, *I found the book* and *Lewis met Chloe*.

The active voice and the passive voice

These contrast two ways of saying the same thing:

Active voice	Passive voice
I found the book. Megan met Ben. The cow jumped over the moon.	The book was found by me. Ben was met by Megan. The moon was jumped over by the cow.

The two types of clause put the same subject matter in a different voice. Passive clauses are made up of a subject and verb followed by an agent.

The book	was found by	me.
subject	verb	agent
Ben	was met by	Megan.
subject	verb	agent

Sentences can be written in the active or the passive voice. A sentence can be changed from the active to the passive voice by:
- moving the subject to the end of the clause
- moving the object to the start of the clause
- changing the verb or verb phrase by placing a form of the verb 'be' before it (as in 'was found')
- changing the verb or verb phrase by placing 'by' after it.

In passive clauses the agent can be deleted, either because it does not need mentioning or because a positive choice is made to omit it. Texts on science may leave out the agent, with sentences such as *The water is added to the salt and stirred*.

4. Punctuation

Punctuation provides marks within sentences that guide the reader. Speech doesn't need punctuation (and would sound bizarre if it included noises for full stops and so on). In speech, much is communicated by pausing, changing tone and so on. In writing, the marks within and around a sentence provide indications of when to pause, when something is being quoted and so on.

Punctuation	Uses	Examples
A	**Capital letter** 1. Starts a sentence. 2. Indicates proper nouns. 3. Emphasises certain words.	1. All I want is cake. 2. You can call me Al. 3. I want it TOMORROW!
.	**Full stop** Ends sentences that are not questions or exclamations.	This is a sentence.
?	**Question mark** Ends a sentence that is a question.	Is this a question?
!	**Exclamation mark** Ends a sentence that is an exclamation.	Don't do that!
" " ' '	**Inverted commas (or quotation/speech marks)** Encloses direct speech. Can be double or single.	"Help me," the man yelled. 'Help me,' the man yelled.
,	**Comma** 1. Places a pause between clauses within a sentence. 2. Separates items in a list. 3. Separates adjectives in a series. 4. Completely encloses clauses inserted in a sentence. 5. Marks speech from words denoting who said them.	1. We were late, although it didn't matter. 2. You will need eggs, butter and flour. 3. I wore a long, green, frilly skirt. 4. We were, after we had rushed to get there, late for the film. 5. 'Thank you,' I said.
-	**Hyphen** Connects elements of certain words.	Re-read, south-west.
:	**Colon** 1. Introduces lists (including examples). 2. Introduces summaries. 3. Introduces (direct) quotations. 4. Introduces a second clause that expands or illustrates the meaning of the first.	1. To go skiing these are the main items you will need: a hat, goggles, gloves and sunscreen. 2. We have learned the following on the ski slope: do a snow plough to slow down. 3. My instructor always says: 'Bend those knees.' 4. The snow hardened: it turned into ice.

Punctuation	Uses	Examples
;	**Semicolon** 1. Separates two closely linked clauses, and shows there is a link between them. 2. Separates items in a complex list.	1. On Tuesday, the bus was late; the train was early. 2. You can go by aeroplane, train and taxi; Channel tunnel train, coach, then a short walk; or aeroplane and car.
,	**Apostrophe of possession** Denotes the ownership of one thing by another (see page 159).	This is Mona's scarf. These are the teachers' books.
,	**Apostrophe of contraction** Shows the omission of a letter(s) when two (or occasionally more) words are contracted.	Don't walk on the grass.
...	**Ellipsis** 1. Shows the omission of words. 2. Indicates a pause.	1. The teacher moaned, 'Look at this floor... a mess... this class...' 2. Lou said: 'I think I locked the door... no, hang on, did I?'
()	**Brackets** Contains a parenthesis – a word or phrase added to a sentence to give a bit more information.	The cupboard (which had been in my family for years) was broken.
—	**Dash** 1. Indicates additional information, with more emphasis than a comma. 2. Indicates a pause, especially for effect at the end of a sentence. 3. Contains extra information (used instead of brackets).	1. She is a teacher – and a very good one too. 2. We all know what to expect – the worst. 3. You finished that job – and I don't know how – before the deadline.

Adding an apostrophe of possession

The addition of an apostrophe can create confusion. The main thing to look at is the noun
– ask:

- Is it singular or plural?
- Does it end in an 's'?

If the noun is singular and doesn't end in 's', you add an apostrophe and an 's', for example: *Indra's house* *the firefighter's bravery*	**If the noun is singular and ends in 's'**, you add an apostrophe and an 's', for example: *the bus's wheels* *Thomas's pen*
If the noun is plural and doesn't end in 's', you add an apostrophe and an 's', for example: *the women's magazine* *the geese's flight*	**If the noun is plural and ends in 's'**, you add an apostrophe but don't add an 's', for example: *the boys' clothes* *the dancers' performance*